BLACKPOOL

THROUGH TIME

Allan Wood &
Ted Lightbown

AMBERLEY PUBLISHING

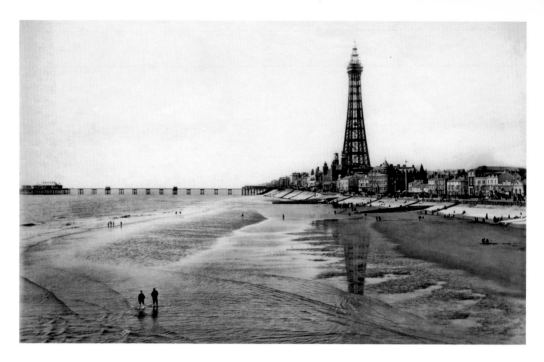

Promenade looking north from Central Pier, 1894.

First published 2010

Amberley Publishing Plc
Cirencester Road, Chalford,
Stroud, Gloucestershire, GL6 8PE

www.amberley-books.com

Copyright © Allan Wood & Ted Lightbown, 2010

The right of Allan Wood & Ted Lightbown to be
identified as the Authors of this work has been
asserted in accordance with the Copyrights, Designs
and Patents Act 1988.

ISBN 978 1 84868 662 5

British Library Cataloguing in Publication Data.
A catalogue record for this book is available from
the British Library.

Typeset in 9.5pt on 12pt Celeste.
Typesetting by Amberley Publishing.
Printed in the UK.

Introduction

It could be said that there can be no history without change, and this is certainly true in the case of a visual history of Blackpool.

Blackpool, whose motto is 'Progress', has changed a great deal since, as a coastal hamlet, it first began to attract visitors from the middle of the eighteenth century. It has grown since those times to become the UK's premier holiday resort and this is primarily due to the 7 miles of wide sandy 'golden' beach, the often bracing west facing sea frontage, the proximity of Blackpool to the industrial towns and people of the North of England and Blackpool's many facilities for letting people have fun.

The photographs in this book allow a glimpse of parts of Blackpool at various times over the last 100 years or so and contrast them with similar scenes in 2009 and 2010. Whilst there have been some recent, excellent developments – the works at St John's Square, St John's School, the Hounds Hill Shopping Development and the coast protection works between North Pier and Squires Gate Lane – it will be apparent from the contrasting photographs that not all change has been progress and, far too often, the sublime or just interesting has been replaced by something

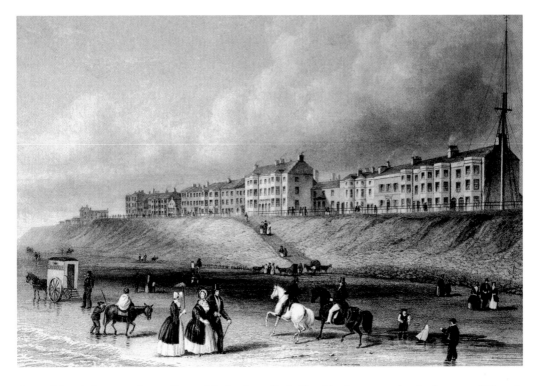

Central Beach from a print *c.* 1850, with the Lane Ends Hotel in the centre (at the bottom of Church Street), Bailey's Hotel (now the Metropole Hotel) to the left, and the flagstaff at the bottom of Victoria Street to the right.

bland or downright awful. Surviving buildings have often lost domes, turrets and pinnacles, either for economic expediency or because such features were considered *passé*. Instead of building *on* its past, Blackpool has tended to build *over* it and progress has often been at the expense of its built heritage.

Blackpool, however, does strive to improve itself and it will always have its glorious natural assets of golden sands and a view of the sea. It is clear that it will continue to develop, re-build and re-package itself as a holiday resort. We can only surmise how the pictures of today will be regarded in a hundred years from now.

Acknowledgements

The authors would particularly like to thank Melanie Silburn for photographs taken by her late father, the Blackpool historian Alan Stott. Thanks also go to Blackpool Central Library, Blackpool & Fylde Historical Society, Blackpool Gazette, Joyce Buckley, Zena Burslam, Norman Cunliffe, Gilbert Davies, Bill Ellis, John Garnham, Antony Hill, Mr. & Mrs. Hudd, Peter Jackson, Ken & Judith Vickers, Scott Silburn, Lister Streefkirk, Ray Maule, Nick Moore, Norman & Kirsty of the Coliseum Hotel, Graham Page, Barry Sidley, Frank J. Smith, W. John Smith, Brian R. Turner, Ian Ward, Richard Wiseman.

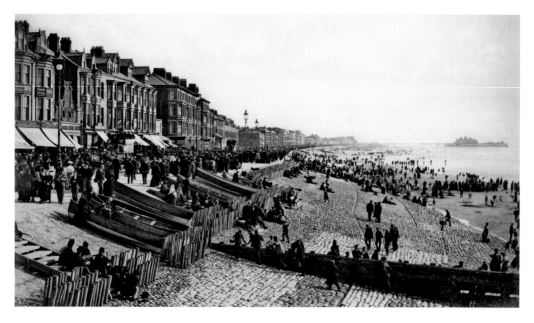

Looking south from Central Pier, 1894.

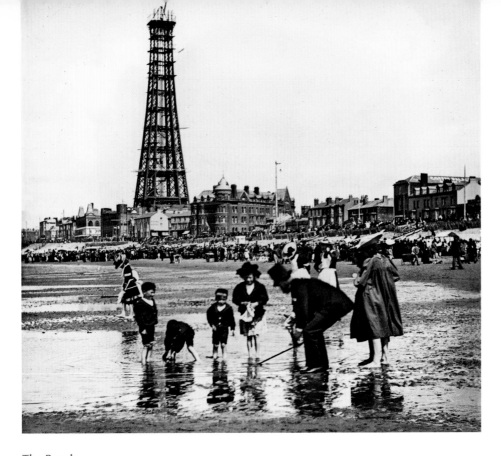

The Beach

A view taken from the beach during the summer of 1893, when work on the Tower structure had reached 380 feet, the level of the first viewing platform. This is contrasted with an early morning view in August 2009. Of the buildings in the earlier photograph, the Tower is the only survivor along this section of the Promenade.

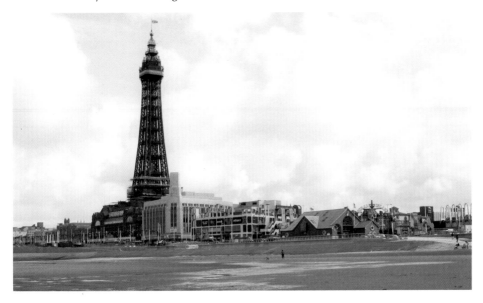

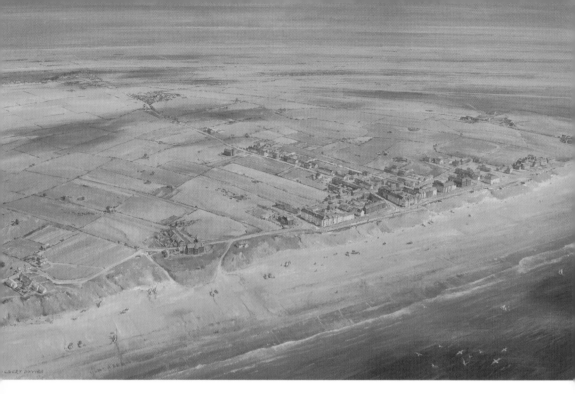

Bird's-Eye-Views

In 2000, Blackpool's local history society commissioned Gilbert Davies to paint a bird's-eye-view of the resort as it would have appeared in 1838, based on the Layton with Warbreck Tithe Award map and early illustrations. Blackpool was then little more than a village and its phenomenal growth during the ensuing fifty years is evident when compared with a bird's-eye-view commissioned by the local historian Ben Bowman in 1890.

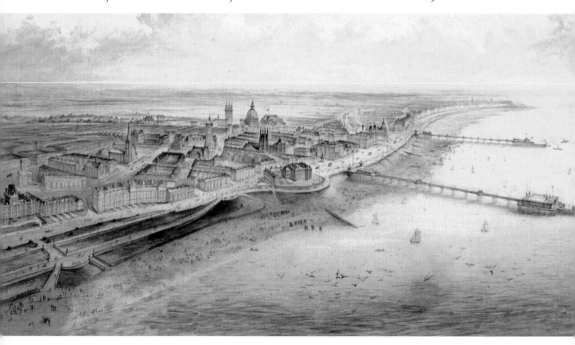

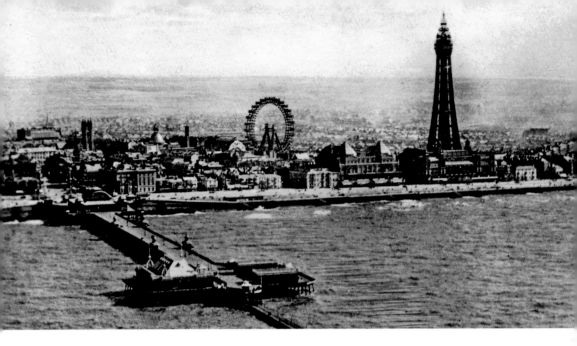

Blackpool from the Air
One of the earliest aerial photographs of Blackpool, taken *c.* 1920, that was probably from an Avro 504K on a pleasure flight from the beach at South Shore. A view today shows the new sea defences, promenade and headlands nearing completion.

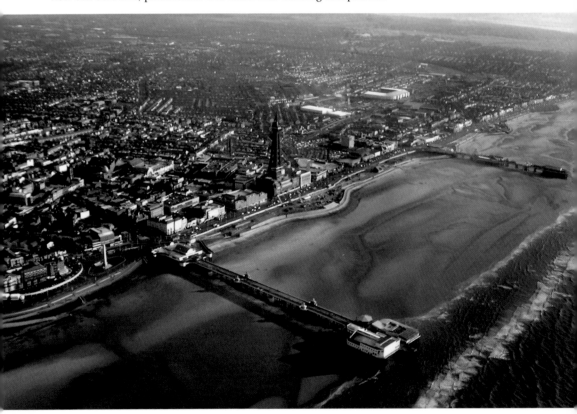

Cleveleys Hydro

Cleveleys Hydro, *c.* 1930, which stood just inside the Blackpool boundary, between Anchorsholme Lane and Kingsway. It had been developed as a hotel in the late nineteenth century from Eryngo Lodge, and the pointed windows of the latter can be seen in the two lower floors of the wing nearest the camera. It was occupied by dispersed Civil Servants during the Second World War, and only partially opened afterwards, being demolished between 1956 and 1959. The site is now occupied by the residential developments of Alconbury Place, Buckden Close and Chatteris Place.

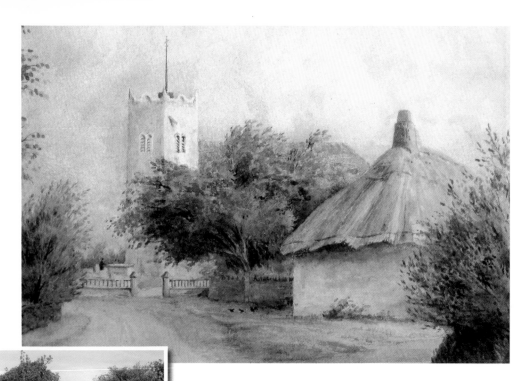

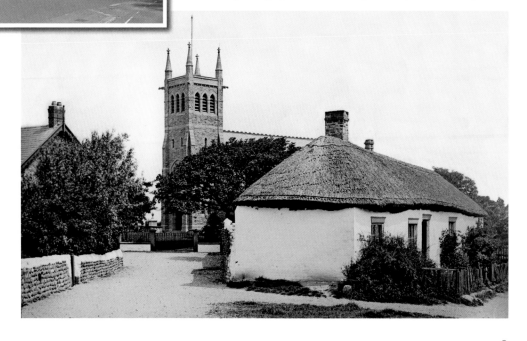

Watercolour by T. Wild

Blackpool was within the parish of Bispham until 1860 and this watercolour by T. Wild shows the former parish church before it was replaced by the present church in 1883. The thatched cottage in the foreground of the painting and the 1890s photograph stood on the site of the present lych gate (inset), erected in 1901. To the left of the photograph is the Sunday School, rebuilt in 1891.

9

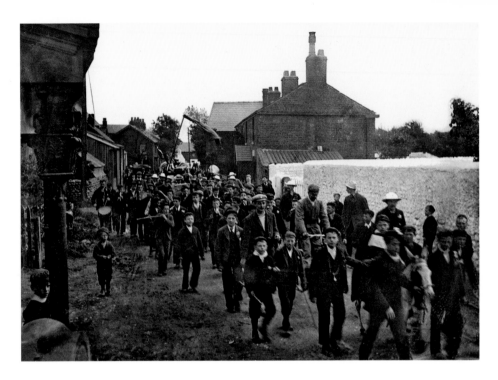

Bispham Village

A parade of youths with a band, and evidently supervised, passing the Smithy (on the left) on its way out of Bispham Village along Church Road, now All Hallows Road, towards the Parish Church in 1897, having proceeded along Bispham Road from Bispham (now Layton) Railway Station. Their visit may have had something to do with Queen Victoria's Diamond Jubilee celebrations. Below is the same view today, towards the mini-roundabout by the Old England pub.

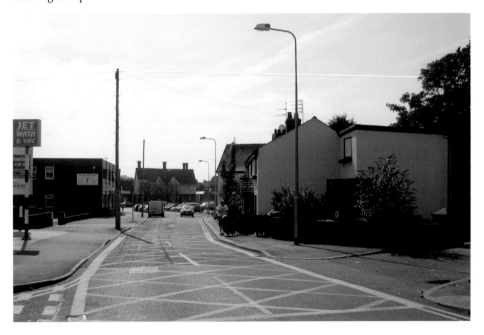

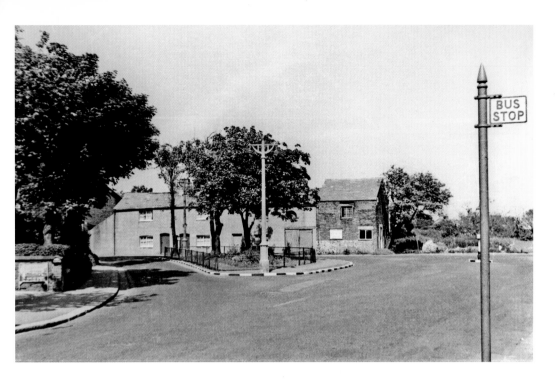

Bispham Village looking east

This is Bispham Village looking east along Red Bank Road about 1950, with All Hallows Road to the left. The triangular island in the centre had been the site of cottages and a post office until they were demolished in 1937. Ingthorpe Road was put through on the right in the 1950s, and a modern shopping centre with a car park replaced Ivy Cottage behind the trees on the left.

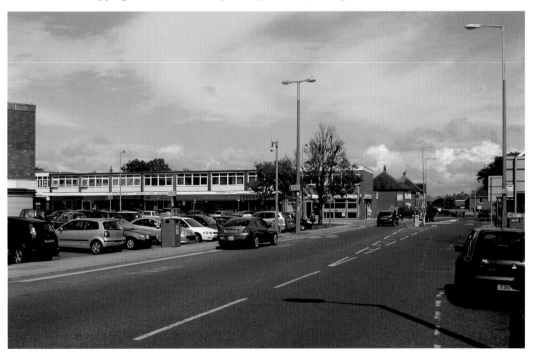

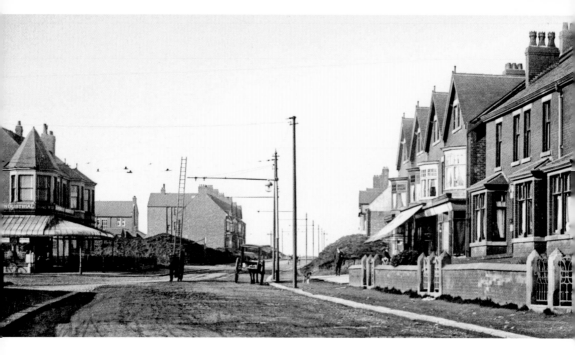

Red Bank Road

This section of Red Bank Road, looking west towards the cliffs *c.* 1913, was created for the Bispham depot of the Blackpool to Fleetwood coastal tramway, which opened in 1898. The tramlines and overhead wires can be seen at the point where they turn towards the depot near Warbreck Drive, which stood on what is now the site of Sainsbury's car park. In the spare land on the left, the Dominion Cinema has come and gone in the period between these two photographs.

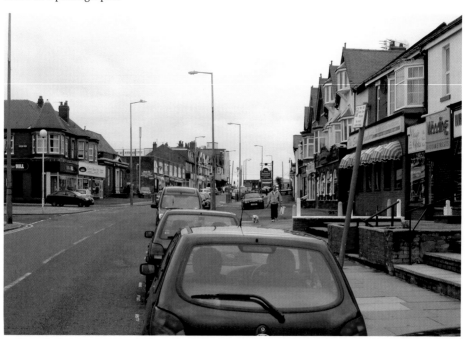

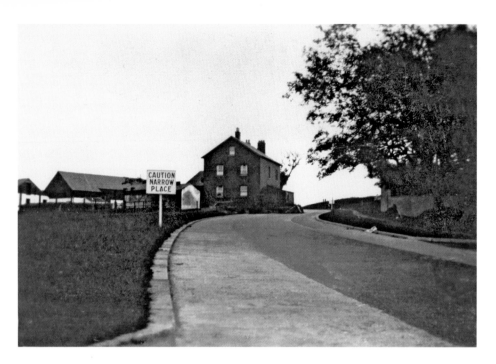

Knowle Farm

The building in the centre is Knowle Farm in the 1920s on the slopes of Beryl Hill (now locally known as Knowle Hill). The farm, as the sign suggests, was an obstruction on the extension of Devonshire Road from Warbreck Hill Road to Bispham, until it was finally demolished in 1931. Behind the wall on the right stood the Knowle, a large house with a lodge, at one time the home of Edwina Ashley, who was to marry Louis Mountbatten.

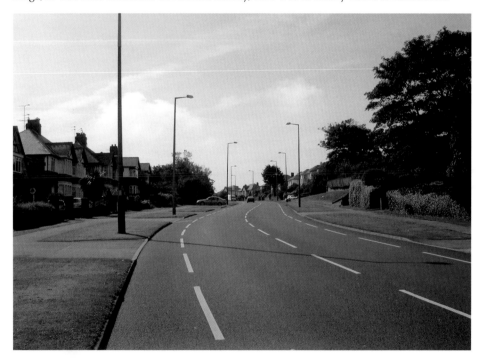

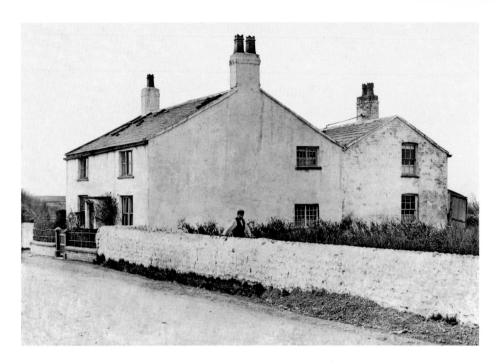

Warbreck Farm

The whitewashed farmhouse of Warbreck Farm, *c.* 1900, seen above, stood on Leys Road just west of the hamlet of Warbreck and close to the present roundabout, at the junction of Warbreck Hill Road and Devonshire Road. It was farmed for many years by the Singleton family until its demolition in 1930. The view below, in 2009, looks west from Leys Road across the roundabout, with its high-mast lighting, towards Warbreck Hill Road.

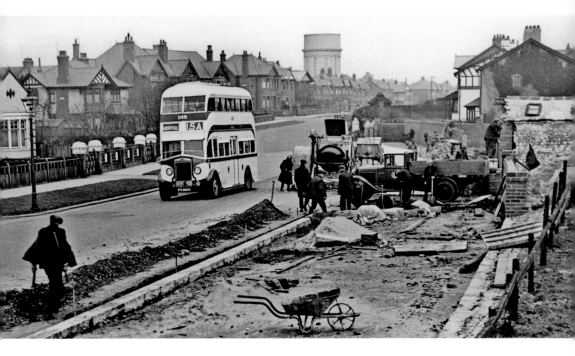

Warbreck Hill Road

This is Warbreck Hill Road looking east towards the Water Tower, which was erected in the early 1930s. The photograph above was taken in February 1938 during the road and footway widening works following the demolition of Bailey's Farm. The site of the farm is now occupied by bungalows on Warbreck Hill Road and Cambray Road. The centre entrance TD4 bus (no. 168) is seen here on the 15a service between Bispham Tram Depot on Red Bank Road and Victoria Hospital.

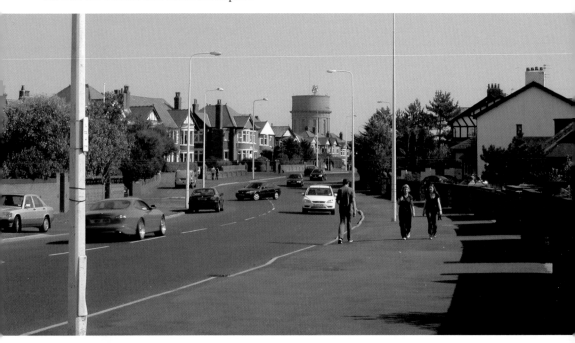

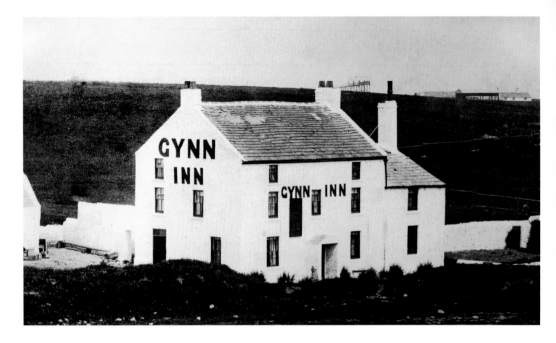

The Gynn Inn

The Gynn Inn, seen here in the 1890s, had been a well-known Blackpool accommodation house from the late eighteenth century. It was demolished in 1921 for road improvements, despite attempts to save it. Its license was transferred to the nearby Savoy Hotel, the present Gynn Hotel replacing the Duke of Cambridge Hotel in 1939. The 'Spare the Gynn' campaign was probably the first of many failed attempts to conserve the resort's built heritage in the more recent past. Its site is now the Gynn roundabout, with its prominent illuminations display.

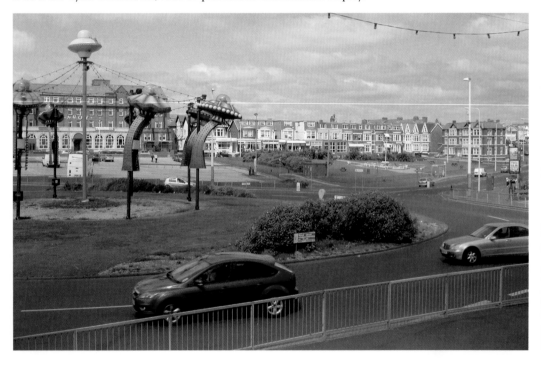

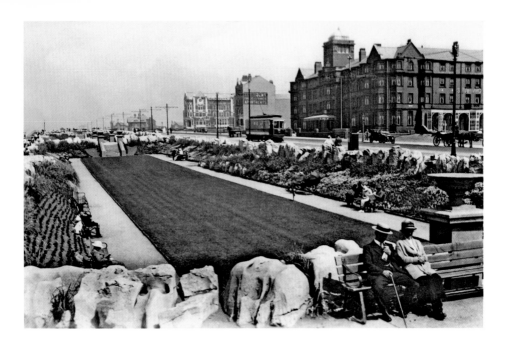

Gynn Sunken Gardens

The development of the area north of the Gynn came with the Blackpool and Fleetwood Tramroad in 1898 and the laying out of the Gynn Estate. The height of the cliffs was much reduced and the material used as fill in sea defence works. In 1915, formal gardens and the Eastlakes' Savoy Hotel opened there. Beyond it, in this 1922 photo, the Mount Hotel stands alone, whereas now, it is part of a terrace of hotels. Further along is the Bryn Tivy, which was extended to become the Cliffs Hotel.

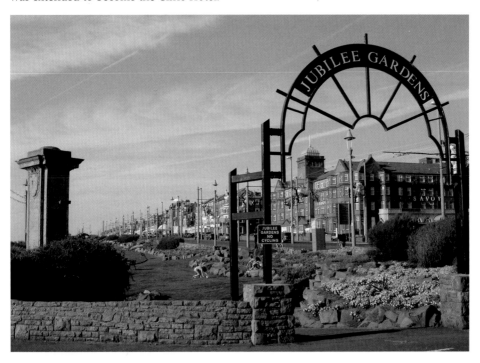

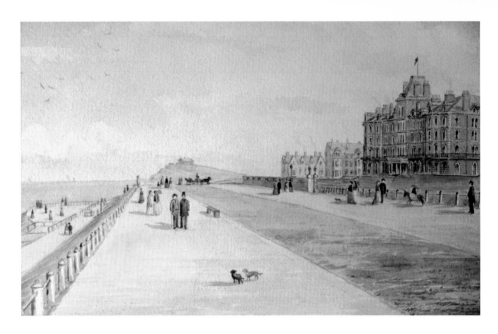

Claremont Park Estate

Claremont Park Estate, between Cocker Square and the Gynn, was developed from 1863. It is depicted above in a watercolour by the Lakeland artist W. T. Longmire dated 1868 when the Imperial Hotel, on the right, was but a year old. In the distance is Uncle Tom's Cabin on the Bispham cliffs. To the left is the Lower Walk, where there is now a Lower and Middle Promenade with Colonnades. The twin tram tracks to Gynn Square were opened in 1900, after the Corporation took control of the once private frontage.

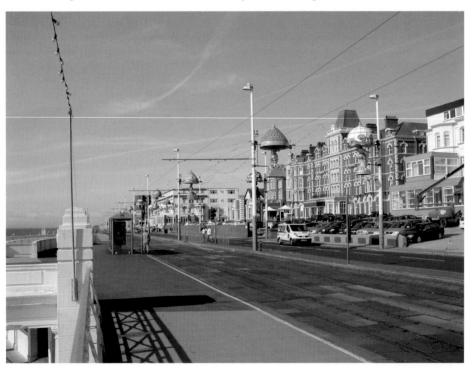

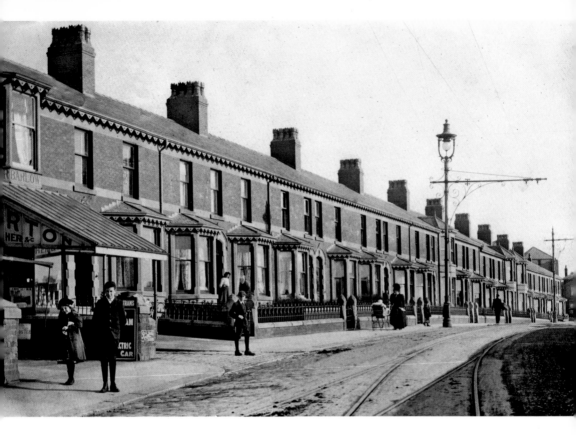

Dickson Road

This is Dickson Road looking south, from near Warley Road, with St Paul's Church, North Shore, in the distance. This section of Dickson Road is seen above, *c.* 1910, when it was Warbreck Road and had a single line tram track between Talbot Road Station and the Gynn. The property to the left with the canopy was a general store in 1910 and is now the Derby Supper Bar.

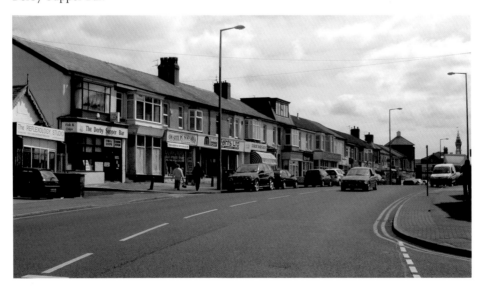

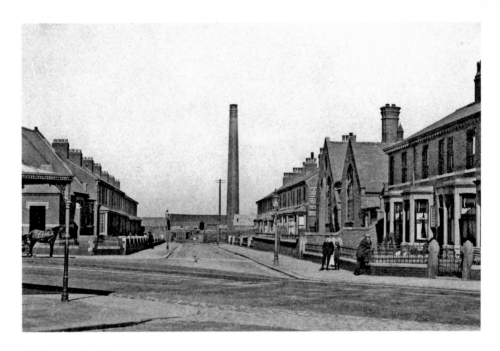

Ashburton Road

Ashburton Road is seen above, *c.* 1910, when it ended at Fielding's brickworks and builder's yard. Fielding built many properties at North Shore in the early twentieth century and Fielding Road is named after him. On the left corner of Egerton Road is the Ebenezer Methodist Church, which opened on 25 May 1900 and was pulled down in 1982. On the right is Ashburton Road Council School of 1904, which was the school's dentist in the 1960s. The houses to the right were, for a long time, a launderette and sweet shop.

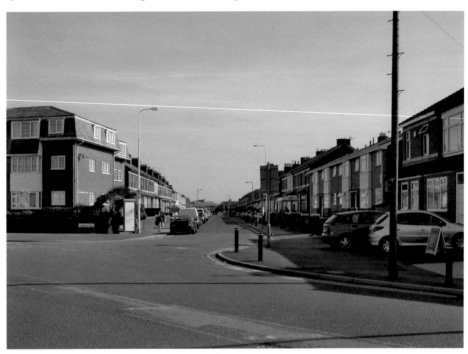

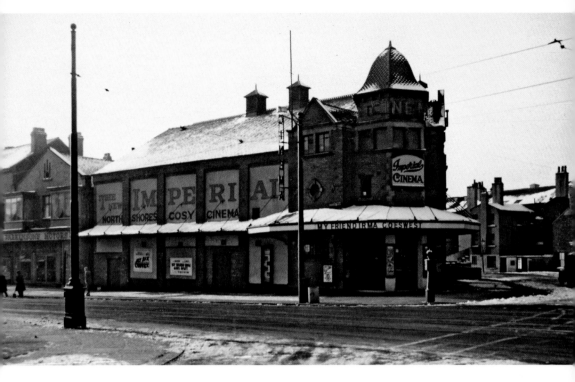

The Imperial Picture Palace

The Imperial Picture Palace opened on 14 July 1913 and was a two tier house with 731 seats. Following a serious fire in April 1939, it was refurbished and modernised, re-opening on 8 July 1939, but it finally closed in 1961. The property was used as an undertaker's premises (Docking's) for many years and is now occupied by the 'Project 102' health advice centre.

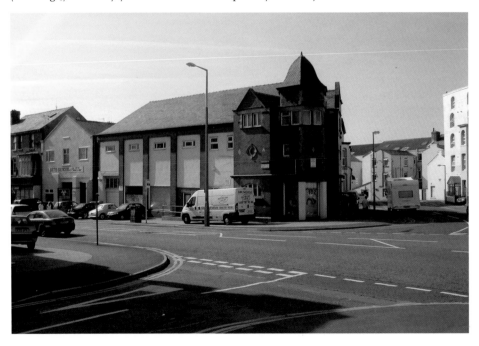

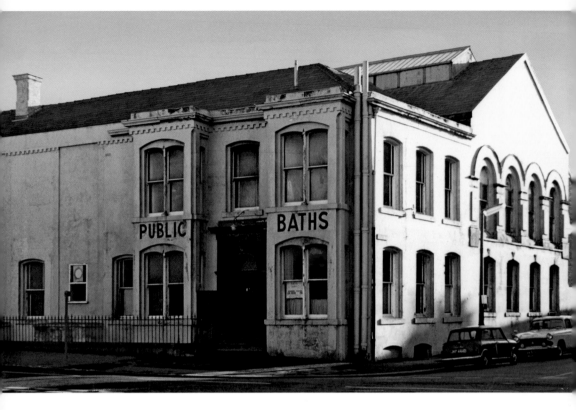

Cocker Street Baths

Cocker Street (sea water) Baths are seen above, just prior to demolition in March 1974. They had been built in 1870, but re-opened in July 1873, having been acquired and modified by Jonathan Read. They were purchased by the Corporation on 19 April 1909. The baths had a surrounding upper gallery and a large skylight. As the authors distinctly remember, the baths were somewhat primitive in their facilities and the water was extremely cold. The site has been used as a car park since demolition.

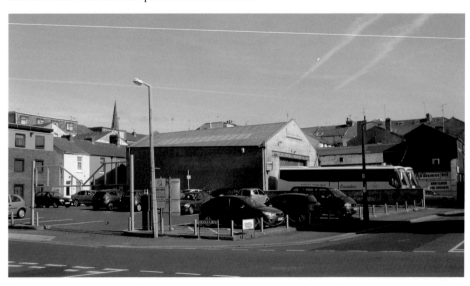

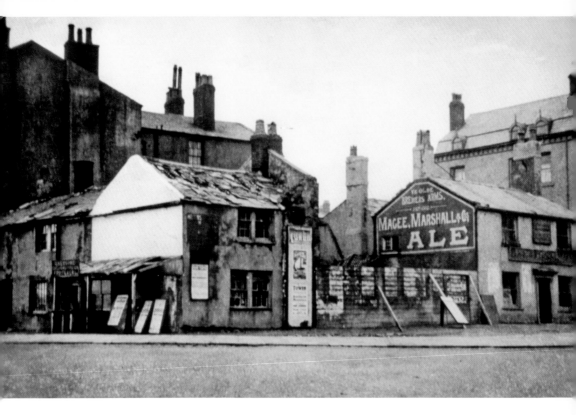

Fumblers Hill

The buildings of the old community of Fumblers Hill, including 'Ye Olde Brewers Arms', are shown above, *c.* 1898, shortly before their demolition. Their site has never been built on since; it became a Council car park opposite the Derby Hotel, now Liberty's Hotel in Cocker Square.

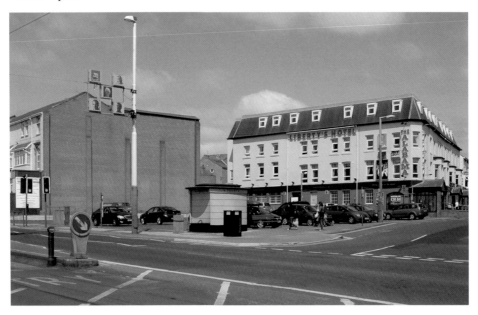

Christ Church

A serious loss to Blackpool's architectural landscape was that of Christ Church, Church of England (founded in 1861 as a tin mission), at the corner of Abingdon Street and Queen Street in 1982, despite a campaign to save it. The reason given was dry rot, but dwindling attendances and its proximity to St. John's Parish Church were probably factors as well. Its site became a car park until the Queen Street Job Centre was erected there in 1993. The church, designed by J. Medland Taylor, had been built in 1870.

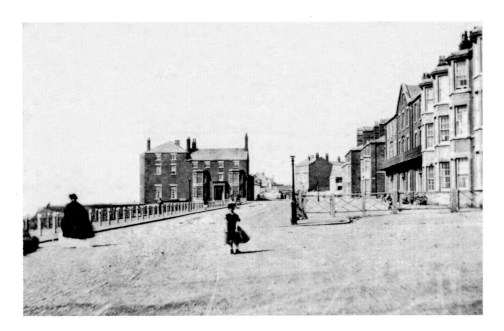

Bailey's Hotel

The very different Blackpool of the early 1860s, showing Bailey's Hotel on a promontory and Albert Terrace on the right, is exemplified by comparison with a 2009 view north from Talbot Square, where traffic now rules. In the distance are the lime-washed buildings of Fumblers Hill. Bailey's Hotel dated from the 1780s, but, following alterations and extensions in the last quarter of the nineteenth century, little or nothing of the original hotel remains within the Hotel Metropole.

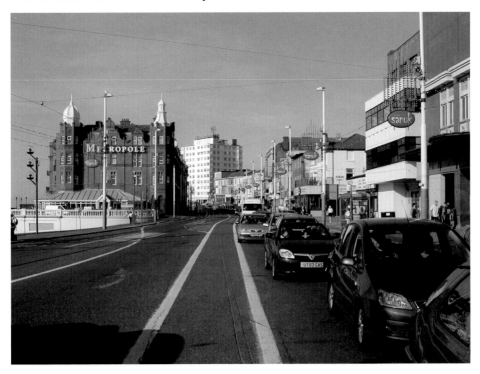

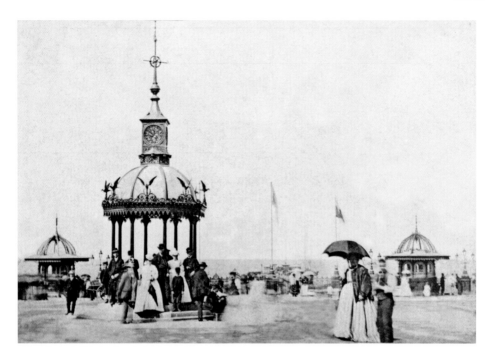

Drinking Fountain

The ornamental drinking fountain in Talbot Square, decorated with cast iron seagulls and a weather vane, was erected in 1870 to coincide with the completion of the new promenade and sea wall between Cocker Square and Station Road at South Shore. North Pier also got a new entrance in 1870, which can be seen in the background of this photograph, taken when the features were new.

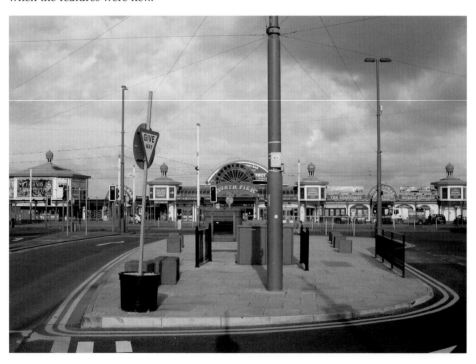

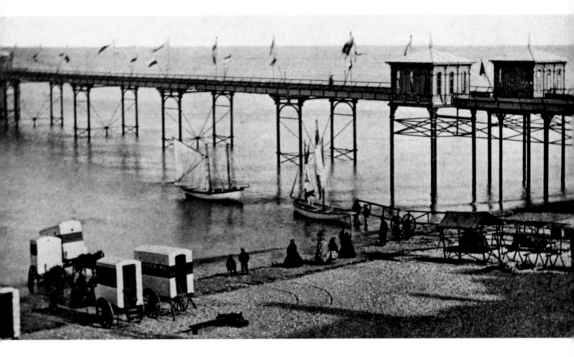

North Pier

North Pier is seen here in the 1860s. It was designed by Eugenius Birch for the Blackpool Pier Company Limited. The pier opened on 21 May 1863 and was constructed using cast iron screw piles and columns supporting wrought iron girders and a timber deck. Originally, the promenade deck was 1,070 feet long and only 28 feet wide. The beach with the bathing huts was more inclined in the 1860s and still had many pebbles and gravel.

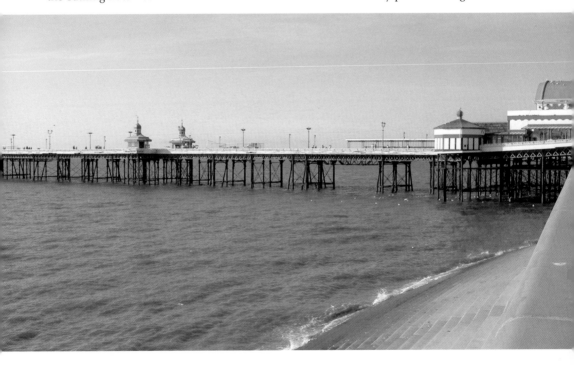

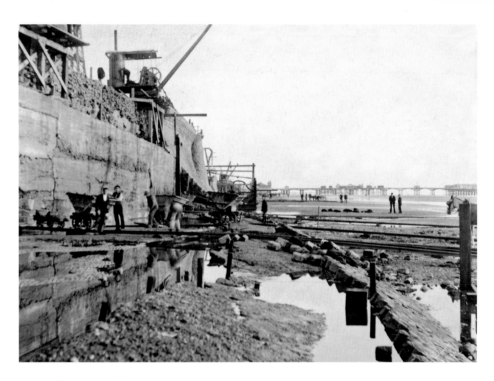

Sea Wall Construction

Starting at South Shore in 1902, the promenade was widened by 100 feet and a new basalt block faced sea wall was constructed as far as North Pier. The works and new promenade were officially opened in July 1905. A century later, they were being replaced by a new sea wall and promenade, which were largely completed in late 2009 with the exception of the 'Tower Headland'. Work on this is due to commence in 2010.

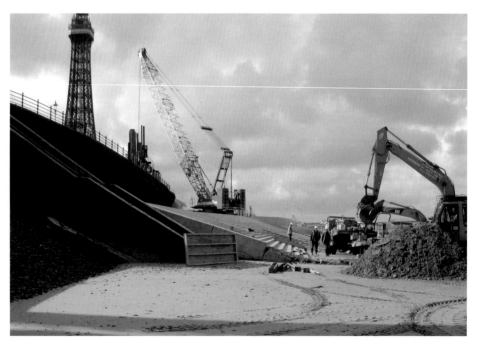

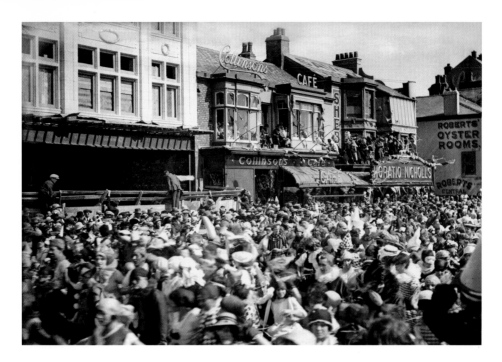

Blackpool's Carnivals

Among the most noteworthy events in Blackpool's history are the carnivals held in 1923 and 1924. They were based on those held in Nice, whose craftsmen were engaged to design floats and bizarre papier-mâché heads and costumes for the week-long events. This is the scene on Central Promenade during the 1923 Carnival. On the left, Feldman's Arcade is nearing completion, whilst near Robert's Oyster Rooms is a Lawrence Wright (Horatio Nicholls) song booth.

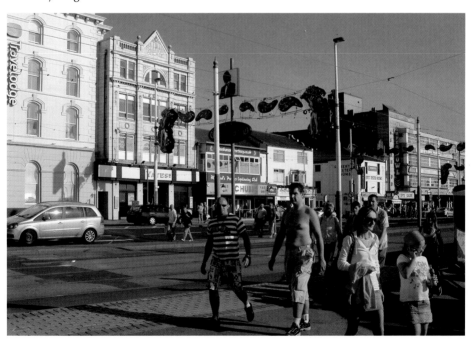

Central Beach from North Pier

The view looking south from the North Pier, about 1867, contrasts greatly with the view in 2009 and the near completion of the new sea defences. The most prominent building in the 1867 view is the County and Lane Ends Hotel at the end of Church Street. At that point the Parade turned a sharp left over 'the Bridge of Peace'. The dark building just beyond is the house named 'West Hey' on the Tower site, and the white building is the Royal Hotel, demolished for a Woolworth's superstore in 1935.

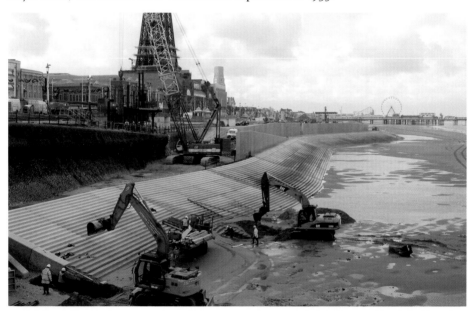

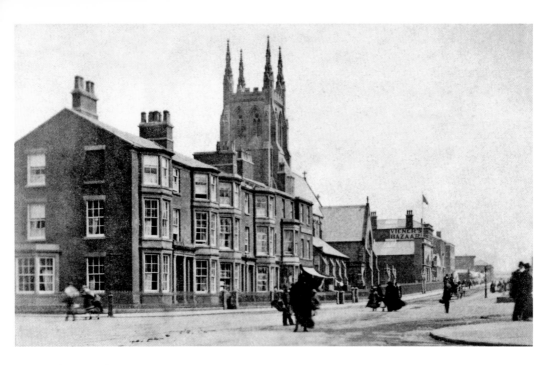

Talbot Road

This is the view looking up Talbot Road from Talbot Square in the mid-1860s. The houses in the foreground soon became shop premises, the best known being a café run for many years by the Jenkinson sisters; this became the Movenpick in the 1960s, then Jenk's Bar and is now Rumours night spot. Sacred Heart RC church (in the centre) opened in 1857, and beyond is Viener's bazaar, which opened in 1859. Apart from wooden huts, the photograph shows only one building between the Railway Hotel and Talbot Road Station.

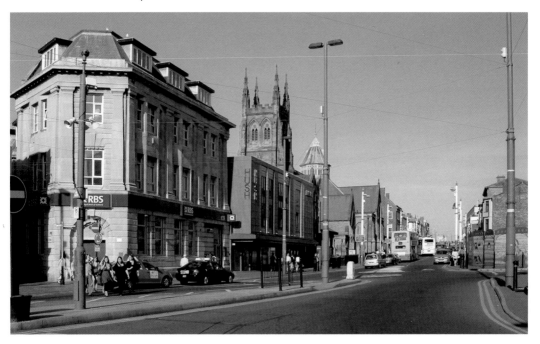

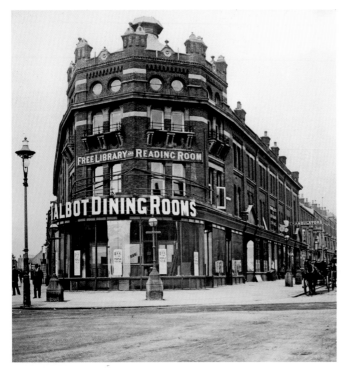

Yates's Wine Lodge
Talbot Road Assembly
Rooms opened in July 1868
with a ball. They included
Blackpool's first substantive
theatre, the Theatre Royal,
and from 1880, Blackpool's
first free library. In 1894,
about the time of this
photograph, the Yates
brothers opened a wine
on the Talbot Road side of
the building and in 1896
acquired the entire premises,
which became the well-
remembered Yates's Wine
Lodge. Since the building's
demolition, following a
catastrophic fire in February
2009, a decorative scheme
has been applied to the
hoardings to ameliorate the
impact on Talbot Square.

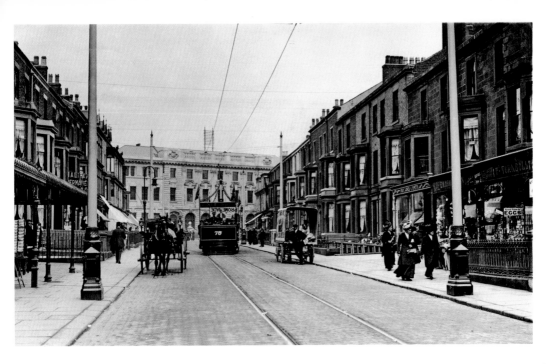

Clifton Street

Looking up Clifton Street towards the new General Post Office on Abingdon Street, a 'toastrack' tram can be seen on the circular tour which had taken it along the Promenade to South Shore, before returning via Waterloo Road, Whitegate Drive and Church Street. The photograph dates from about 1912, when some of the boarding houses were already becoming shop premises. Now building societies and restaurants predominate.

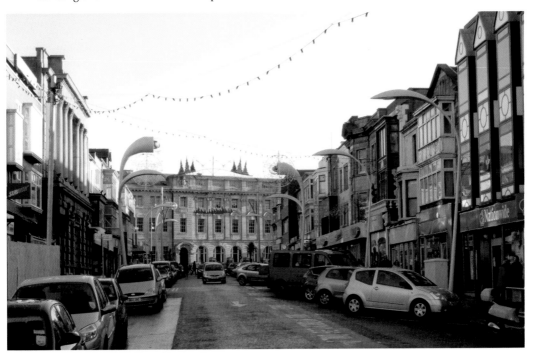

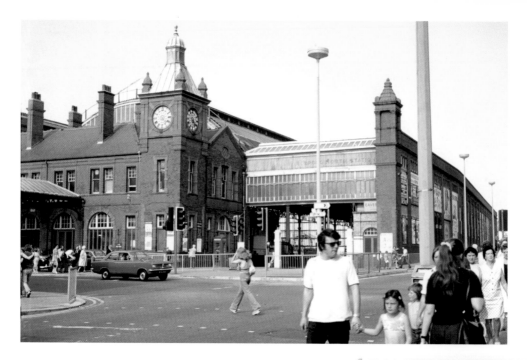

North Station

North Station in 1973, with its ticket office inset, shortly before the demolition of the main building, the removal of tracks and the conversion of the former 1930s excursion hall near High Street into the main station. The distinctive red terracotta and brick building had been completed in 1898, having replaced the original classical Talbot Road Railway Station of 1846. In 1979, a Fine Fare supermarket opened on the site, with car park above. After several changes of ownership the premises are now a Wilkinson's store.

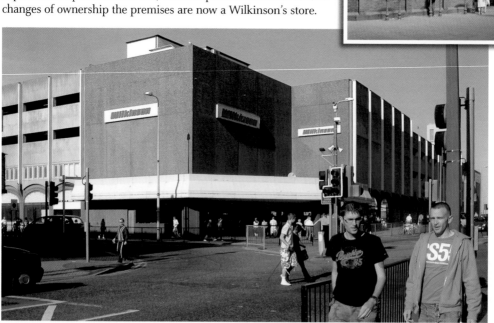

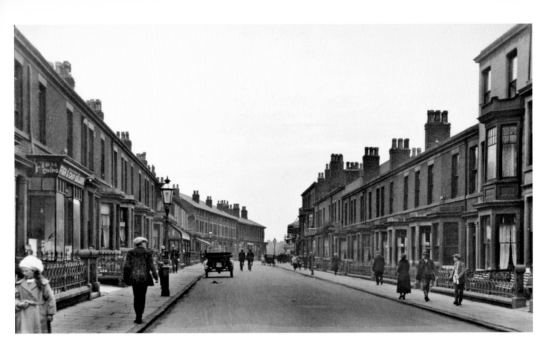

Topping Street

This view is looking south along Topping Street in the early 1920s, when there were only a few shop premises among the boarding houses. By the end of the following decade the opposite was the case. Today it is a one-way street of cafés and restaurants busy with traffic as a result of a pedestrian area nearby.

The King's Arms

The King's Arms, at the corner of Talbot Road and Swainson Street, is seen here in 2006 shortly before its demolition. Latterly it had become the Flying Handbag and, like The Flamingo club beyond, above what had been garage premises, it was part of Blackpool's gay scene. The property was demolished in 2007 as part of the Talbot Gateway redevelopment, as was the Indoor Bowls Centre in 2009, behind the hoardings of the photo below. The centre had opened on Lark Hill Street on 23 April 1988.

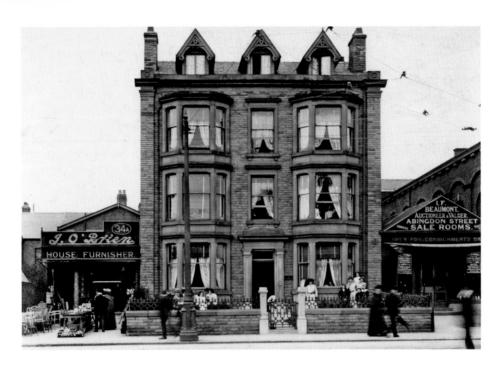

Crowther's Boarding House

Crowther's boarding house stood on Abingdon Street, facing Clifton Street, and must have afforded a view of North Pier and the sea. In the 1870s it was only two stories high. It is seen above in February 1907 when, along with the Union Baptist Chapel, partially in view on the right, it had been acquired by the Government as the site of a new General Post Office, which opened on 8 November 1910. The post office is seen below with four of its eight listed red telephone boxes.

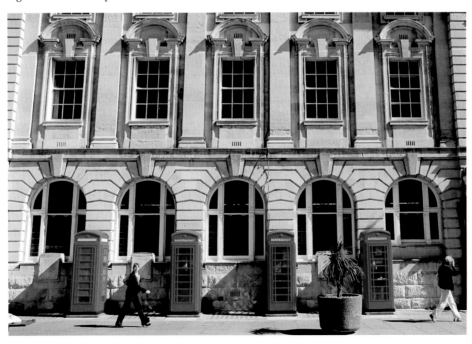

Police Station

Blackpool's first police station was in Bonny Street, but in 1862 the headquarters moved to new premises, next to the Union Baptist Chapel on Abingdon Street, seen here *c.* 1880. When a new police station and courts opened on South King Street in 1893, the old station was acquired by the joiner and builder Thomas Houldsworth Smith, who added a storey and a mock-Tudor façade. In the early 1900s it became the Jackson Brothers' garage, and in 1927 Abingdon Street market.

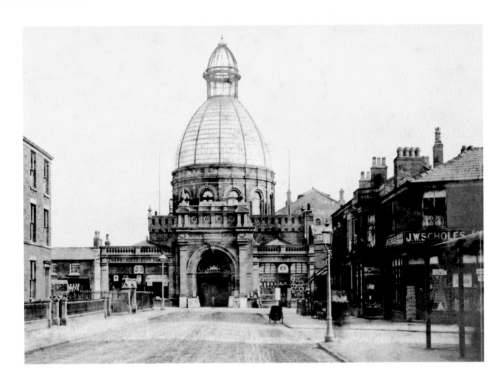

Winter Gardens

The original Church Street entrance of the Winter Gardens is seen above, about two years after its opening in 1878. To its left, the first Opera House was built in 1889, and with its replacement in 1911 came a new façade to accommodate a grand foyer. The façade was extended in the same style in 1939, with the construction of the present Opera House, the third on the site. On the right is Birley Street, and the Yorkshire Bank occupies the site of the houses on the left.

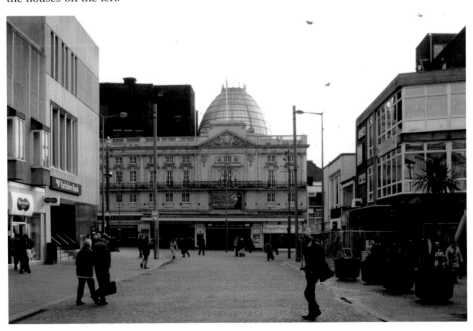

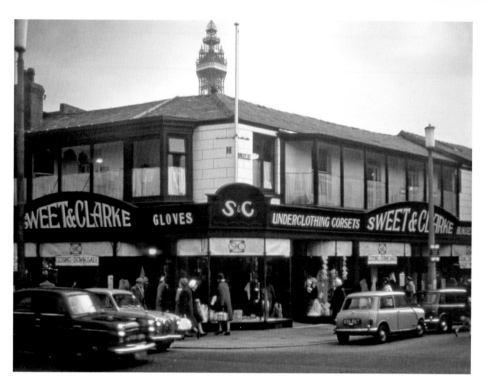

Sweet & Clarke's

By the time of its demolition, *c.* 1966, Sweet & Clarke's ladies and children's outfitters at the corner of Abingdon Street and Birley Street was considered old-fashioned and quaint. A system of overhead wires, dating back to 1919, transferred takings from the counters to a central cashier's booth. The corner was redeveloped for shops with the Oyster Catcher Restaurant, as seen above. It is now the West Coast Rock Café and the view of the Tower has gone.

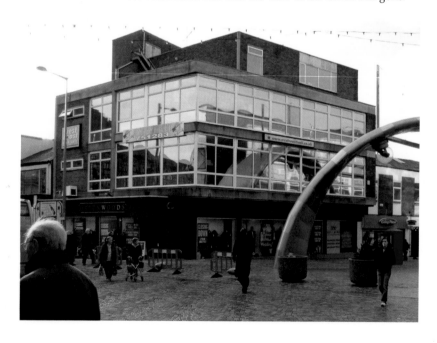

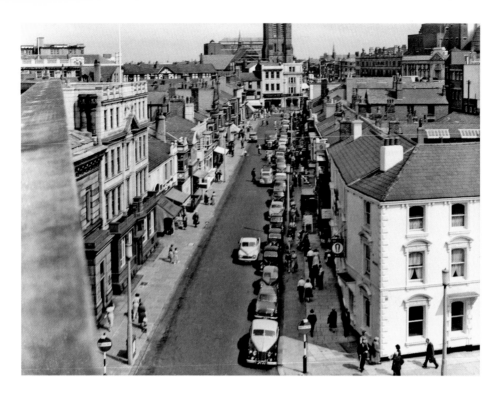

Birley Street

Birley Street, seen in July 1959, from the roof of the Municipal Buildings, before the Crown Hotel, on the right, was rebuilt in 1963. The street was pedestrianised in 1996 and from 2009 has been dominated by the arguably over-engineered 'Brilliance' light display, which is somewhat reminiscent of some giant stainless steel mudguards having been deposited there.

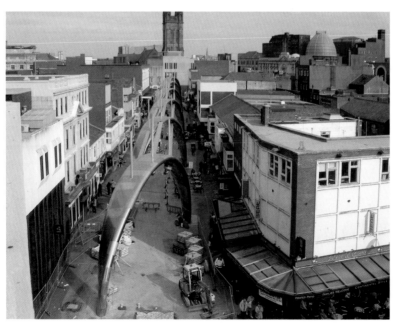

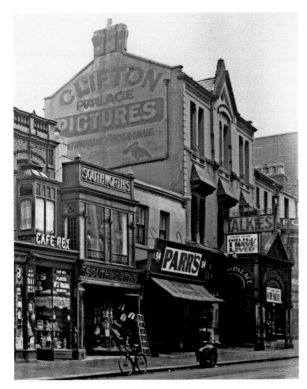

The Clifton Palace Cinema
The Clifton Palace cinema (700 seats), seen here in the early 1930s, opened in 1910, in premises that had been the Clifton Livery Stables and the Liberal Club between 1879 and 1898. It re-opened as the Tatler News Theatre in 1950, part of the Fylde Cinema chain, before becoming a furniture shop in 1954. It is now Poundland.

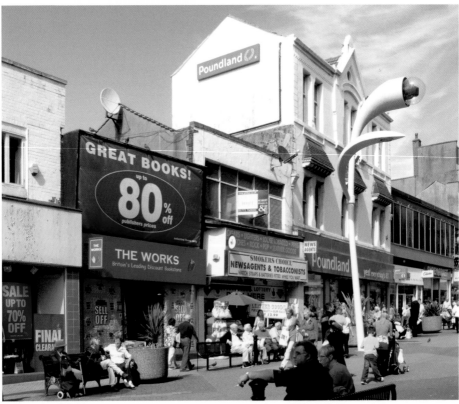

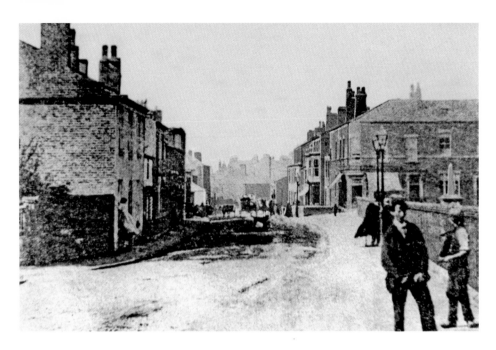

Church Street

Looking down Church Street in the 1860s. Beyond the railings surrounding St John's churchyard are houses on Abingdon Street. On the extreme left is the entrance to St John's Vicarage. The cottages on the left and the vicarage were demolished at various stages of the development of the Winter Gardens complex.

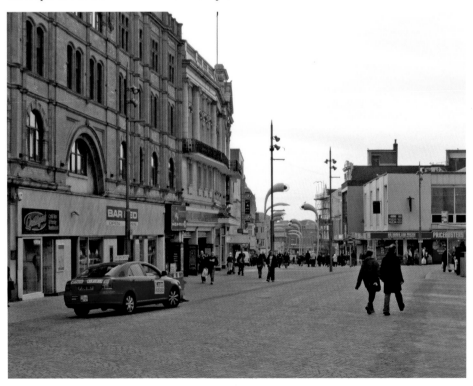

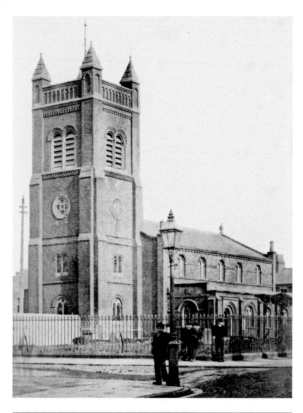

St John's Church

The first St. John's Church was consecrated as a chapel of ease from Bispham Parish Church in 1821 and became a parish church in its own right in 1860. Over the years it underwent several alterations, the most significant being a handsome new tower in 1866. Only eleven years later the whole church was rebuilt. To the left of the tower can be seen a support pole for Blackpool's first telegraph wire, linking the Post Office at Adelphi Street with Talbot Road Station from 1870.

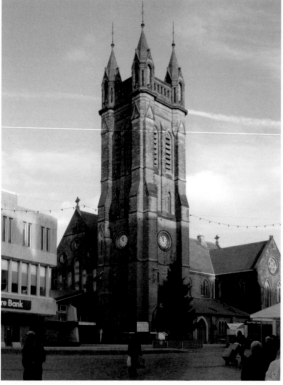

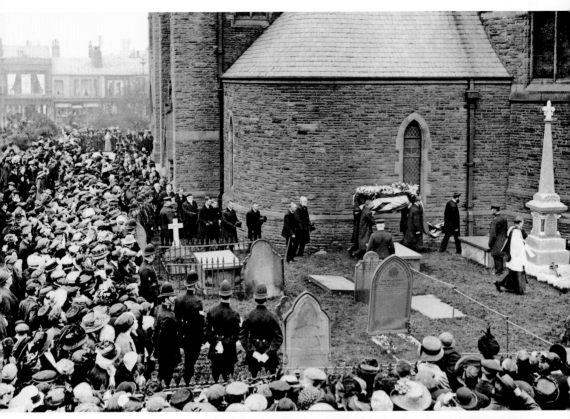

William Henry Cocker

The funeral of William Henry Cocker, Blackpool's first mayor in 1876 and a great influence on the town's development during the latter half of the nineteenth century, took place following his death on 14 April 1911. His grave and that of Rev. William Thornber at the eastern end of the church were the only ones to be retained after the rest were transferred to Layton Cemetery in the 1920s, to allow for road widening. In 2009, the whole area was paved with stone sets to create St. John's Square.

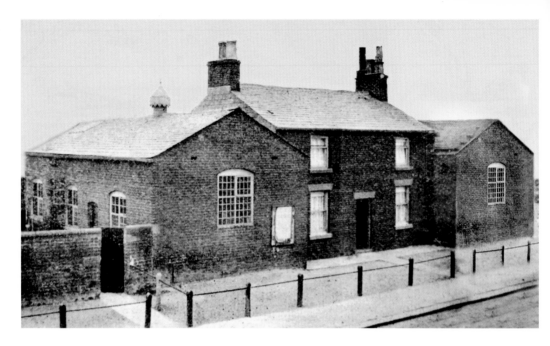

St John's School

St. John's School, Church Street, opened in 1817, as the National Schools on Raikes Hill. As shown in this Victorian photograph, it comprised boys' and girls' schools separated by a master's house. In 1895, new buildings were added and the original buildings were incorporated into a row of shops along Church Street. There they remained until the entire site was cleared for a splendid new school, seen here on the day it opened, 9 September 2009.

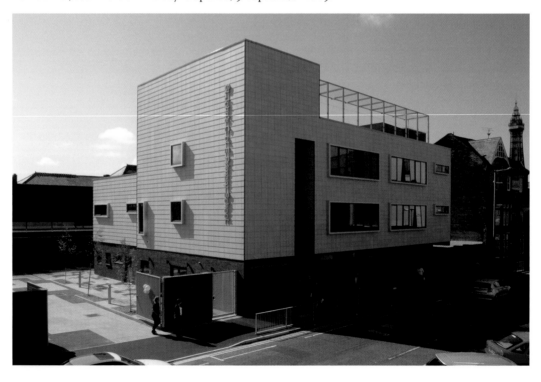

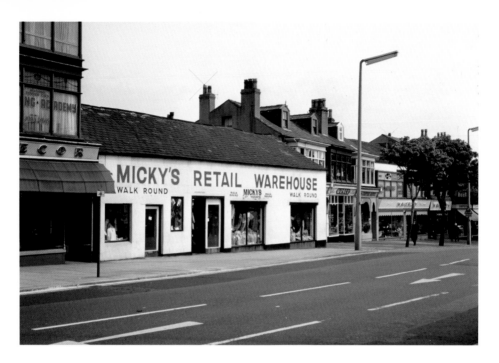

Raikes Smithy

Before its demolition in 1989, the former Raikes Smithy on Church Street, opposite Park Road, was reputedly the oldest surviving building in Blackpool. It is seen here in 1969, when it was generally known as Micky's Market. In 2007 the nearby shop premises, the Grosvenor Hotel and the former Marks Warehouse on Cookson Street were pulled down to create another 'temporary' car park for the town.

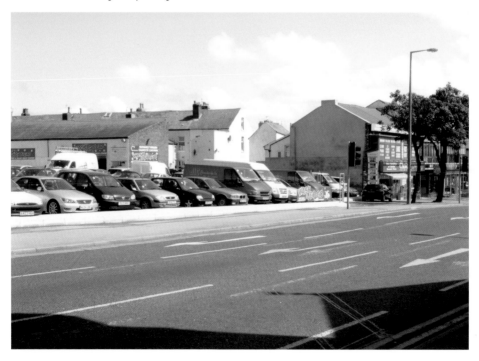

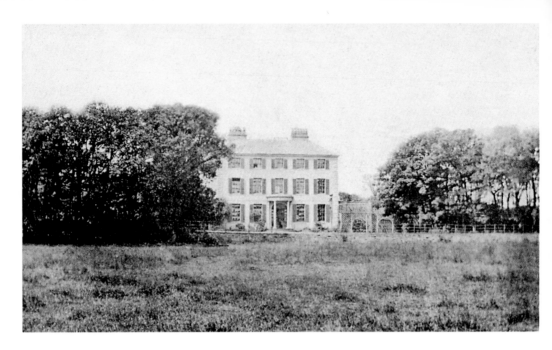

Raikes Hall

This view of Raikes Hall is the only known photograph to show it in the 1860s, before the Sisters of the Holy Child, Jesus, moved to their new school at Layton Hill and its grounds became pleasure gardens. Raikes Hall Gardens were opened to the public in 1872, but following their closure in 1901 the land was developed for housing, as can be seen from an approximate modern view from the lower end of Leamington Road. However, the eighteenth-century house survived, becoming the Raikes Hall Hotel on Liverpool Road.

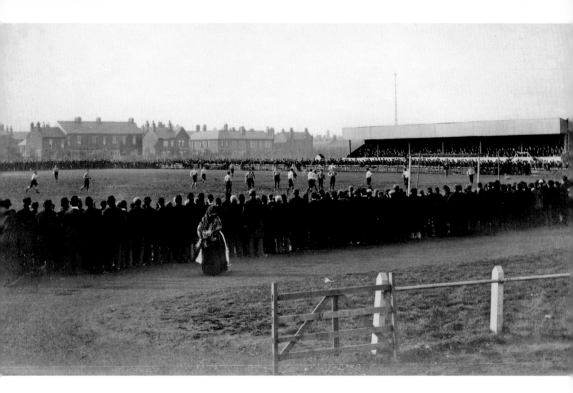

Football at Raikes Hall Gardens

Blackpool Football Club was founded on 26 July 1887 and played at Raikes Hall Gardens (and also for a period at the Athletic Ground, near the present cricket club) before their closure forced the club to find a new pitch at Bloomfield Road in 1901. In the background of this photograph are houses on the west side of Raikes Parade. The view cannot be replicated now, due to the houses of Longton and Lincoln Roads.

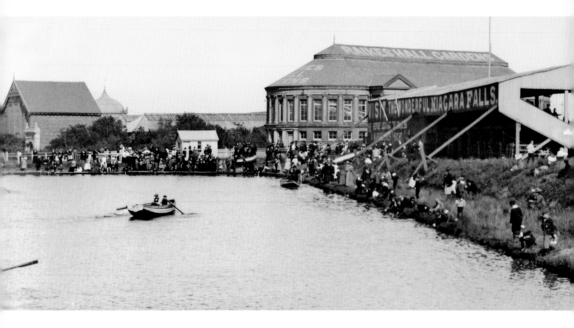

Raikes Hall Gardens

Raikes Hall Gardens is seen here in the 1890s, with its boating lake, grandstand and theatre. From the mid-1890s its future was in doubt and, despite suggestions that it should become a public park, in 1896 land at its perimeter was sold for building. Its last full season was in 1901, but in November its lake was drained and the following year new streets were laid out.

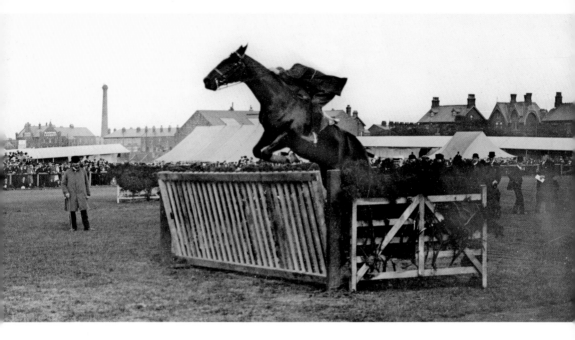

Show Ground

With the demise of Raikes Hall, in 1902 land was obtained for agricultural shows on the north side of Talbot Road, near the present Devonshire Road. Shown here is an event taking place there. In the background, on the right, are Victoria and Queen Villas at Queenstown. Behind the horse can be seen the Yeomanry's drill hall, which survives. To the left is Blackpool Laundry, which, as a furniture showroom, was destroyed by fire in 1990. Houses on Devonshire Road prevent an accurate modern view.

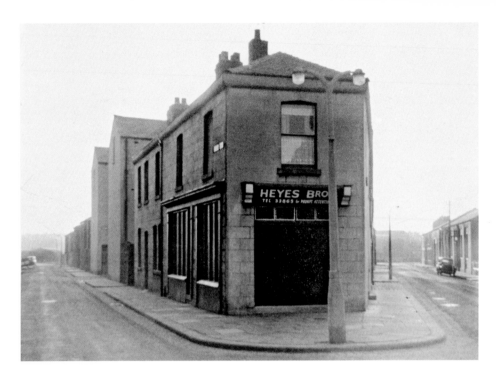

Queenstown

This is the Heyes Brothers furniture store, at the junction of Wildman Street and St. Joseph's Road, Queenstown, which developed in the 1870s with rows of mean terraced housing. From the outset it had a reputation for domestic squabbles and drunken fights, despite a police station nearby and St. Joseph's Mission, which is visible on the right, but is better remembered as Georgie Blackburn's store. Police patrolled the area in pairs. It was all swept away in the early 1960s, when four high rise flats were built, shortly followed by a taller fifth block.

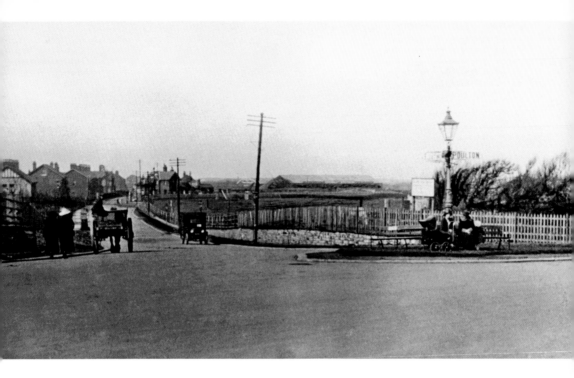

Hoo Hill

A mid-1920s view from Hoo Hill, Layton, towards the level crossing on Bispham Road and Layton Railway Station. It was then known as Bispham Station, despite being within Little Carleton's boundary! In the distance Crossley's Sawmill can be seen. The level crossing was made redundant by what is still known as Crossley's Bridge, which opened in 1932. The land to the centre right was Hoo Hill Farm and is now occupied by the residential property of Benson Road, Delaware Road and Oregon Avenue.

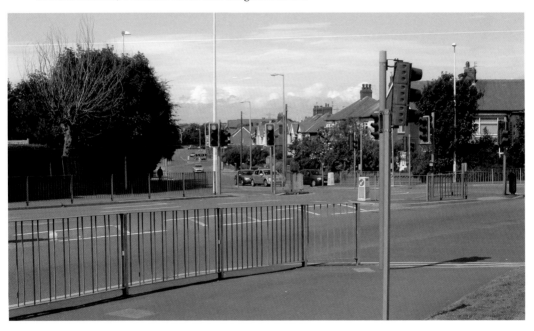

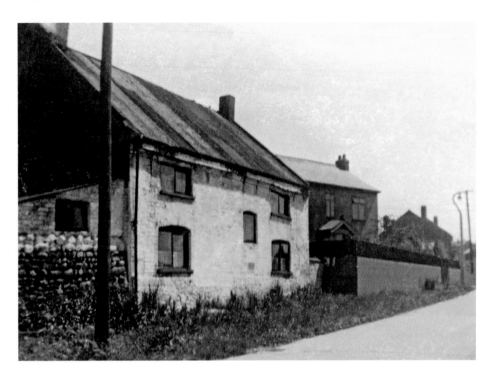

Grange Farm

Grange Farm stood in the hamlet of Little Layton, a semi-rural community quite distinct from housing developments around Westcliffe Drive. It gave its name to Grange Park Estate, which along with the construction of St. Walburga's Road led to the demise of the hamlet in the 1950s. In the photograph, only Marine Villa survives.

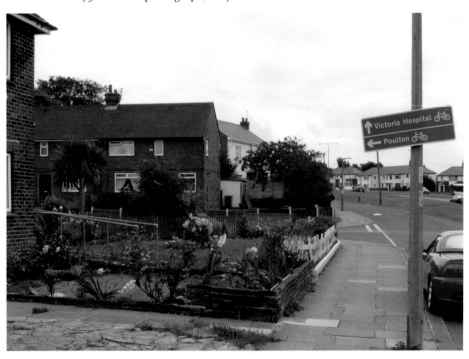

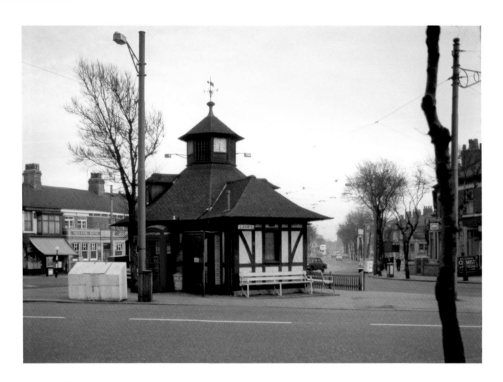

Devonshire Square

The rustic tram shelter and toilets at Devonshire Square is captured here in 1963, the year after trams stopped running along Whitegate Drive. Erected in 1920, it was one of the first of many distinctive buildings that J. C. Robinson designed for the Council between the wars. The replacement toilet block of 1965 and subsequent landscaping may have seemed an improvement at the time.

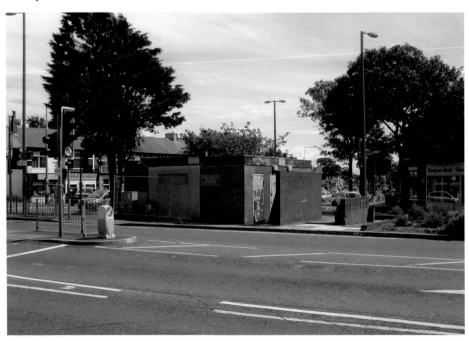

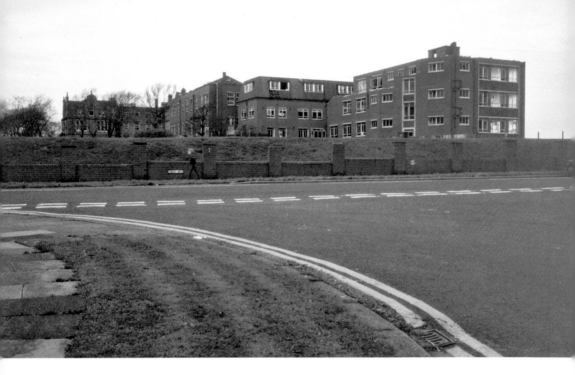

St Joseph's College

St. Joseph's College, seen here in January 1985 when demolition had just begun, had its origins in a private school established in 1918 at Layton Mount (on the left). From 1923 the school was run by the Christian Brothers. It expanded over the next fifty years and was latterly part of St. Mary's High School. 'The Cloisters' housing estate now occupies the site and the adjacent Collegiate Girls' Secondary School's playing field became the site of the main Blackpool Fire Station, formally opened on 10 April 1987.

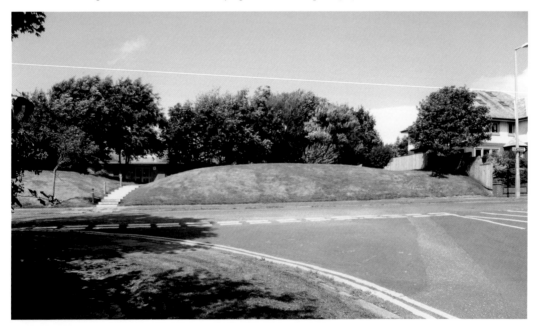

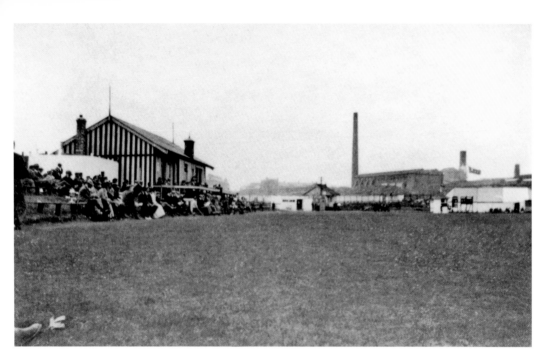

Blackpool Cricket Club

Blackpool Cricket Club moved from Raikes Hall Gardens in 1893, after boats from its lake had been dragged across the pitch during the previous winter. Its new home was the Athletic Ground. In the 1920s, Stanley Park was laid out on three sides of the ground. On the left is the original pavilion, which burnt down in 1925 as the new one, seen in the modern photograph, was nearing completion. Beyond is a rare view of Fenton's brickworks and chimney, later the site of Stanley Park's rose garden.

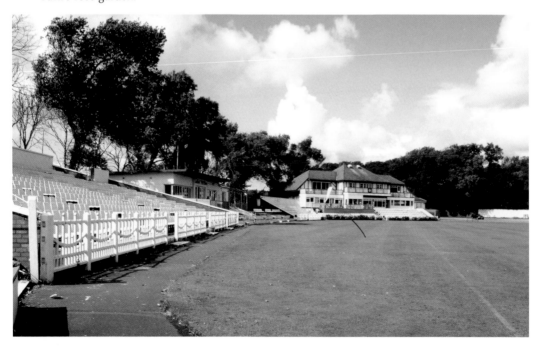

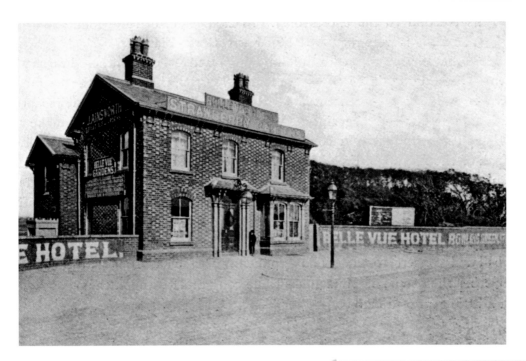

Belle Vue Hotel

The original Belle Vue Hotel on Whitegate Lane dated from the 1860s and had extensive pleasure gardens, replete with a bandstand and a dancing platform. In 1913 a new hotel was built on a plot to the south and the site of the original hotel became the Belle Vue Garage. The garage was rebuilt in the modernist style in the 1930s, but it became dilapidated in recent years, as can be seen from the photograph below taken in 2006. It was finally demolished in 2009.

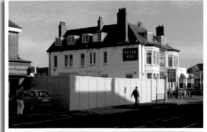

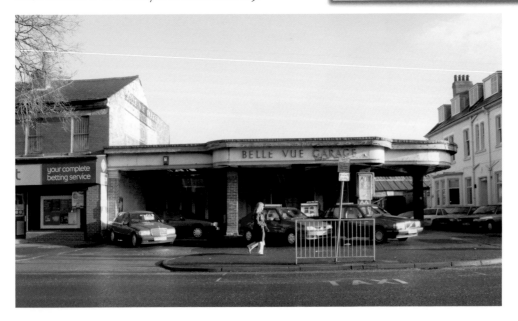

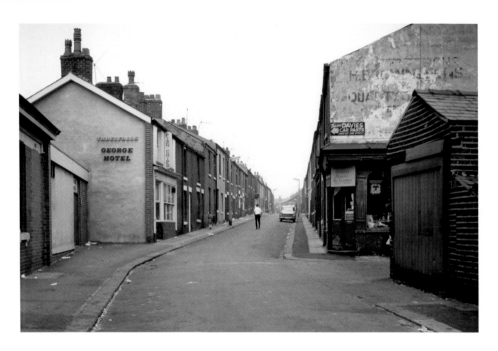

Ibbison Street

Despite being off Central Drive, Ibbison Street could be regarded as having been the principal street of the close-knit Revoe community, an area of late Victorian speculatively-built terrace houses, populated by workers in the holiday industry, particularly with donkeys and on the Golden Mile. Like Queenstown, it had a reputation. Ibbison Street's houses were pulled down in 1974, and replaced by the sheltered housing and community centre of Ibbison Court. The George Hotel to the left, on Central Drive, survives.

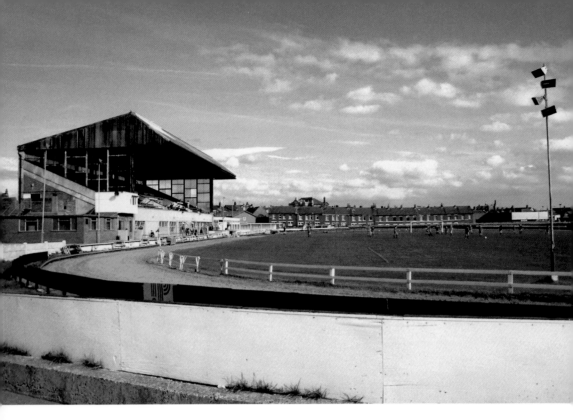

Blackpool Borough Rugby League Club

Blackpool Borough Rugby League Club's ground and greyhound racing stadium adjacent to Rigby Road was built on what had been railway sidings and the coal yard of the gasworks. Intriguingly, the 1845 OS map has 'Ruin' marked at the north east corner of the site. The late Alan Stott thought this might have been one of the original three 'Pool Houses', from which Blackpool developed in late medieval times. An Odeon cinema and other facilities replaced the rugby ground in 1998.

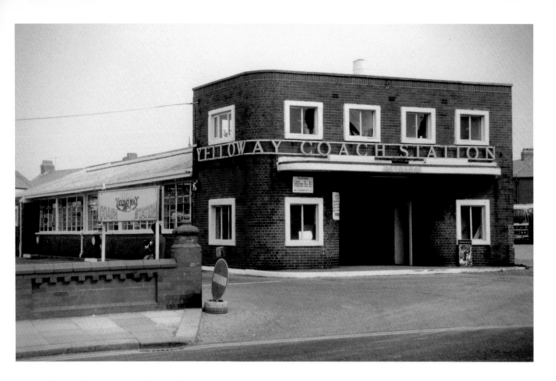

The Yelloway Coach Station

The Yelloway Coach Station was built close to the site of Bloomfield, Dr. Cocker's bungalow, after which Bloomfield Road takes its name. The bungalow, of which there are no known photographs, became a club with a bowling green. Magnet joinery built a kitchen showroom there, close to Ansdell Road, which became a Lidl store in 1995. Lidl have since rebuilt their store on its former car park with a new car park on the site of the old supermarket.

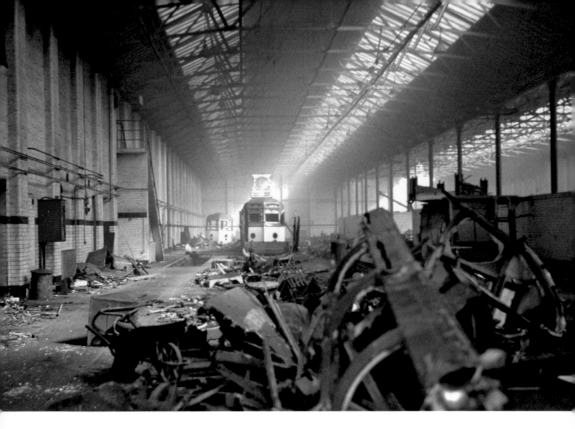

Marton Tram Depot

The interior of Marton tram depot, as photographed by the late Alan Stott during the spring of 1963, when the Marton route had closed and surplus trams were being scrapped. The premises were then used for some years by Thomas Motors, a Ford dealer. A petrol station was later established there and more recently a small supermarket was added.

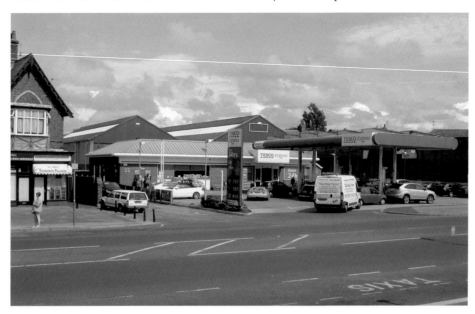

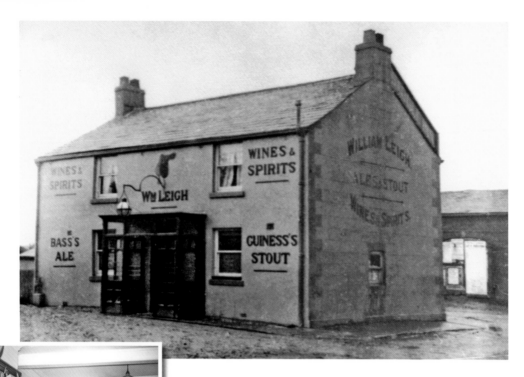

Saddle Inn, Great Marton

The Saddle Inn at Great Marton, on the corner of Preston Old Road, is reputed to be the oldest public house in the Blackpool area. This photograph was taken in the 1890s, before another bay was added at the south of the building, and shows the rear with the barn of Hill's Farm across Whitegate Lane. Inset is a photo of 'the Commons', a room where locals would debate issues of the day and where, into modern times, women were not allowed.

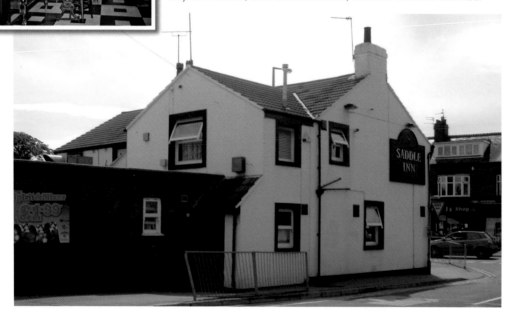

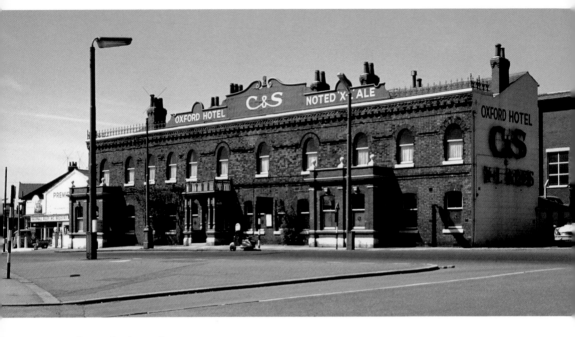

The Oxford Hotel

The Oxford Hotel, at what had been Marton Green, gave its name to the area where Waterloo Road, Preston New Road, Whitegate Drive, Park Road, and others all come together. It is seen here in 1963, when laburnums still grew against its walls of brown local bricks. No doubt its appearance did not fit in with the corporate image of a particular brewery following a series of take-overs, and the 'improvement' can be seen in a recent photograph of the pub.

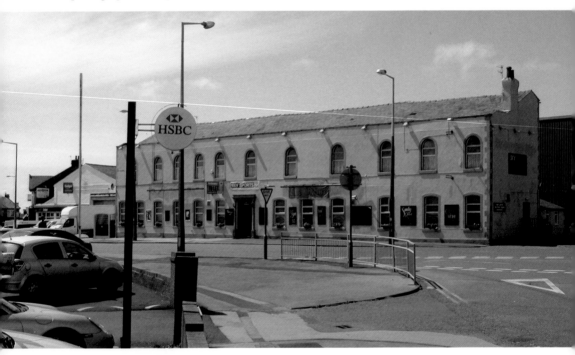

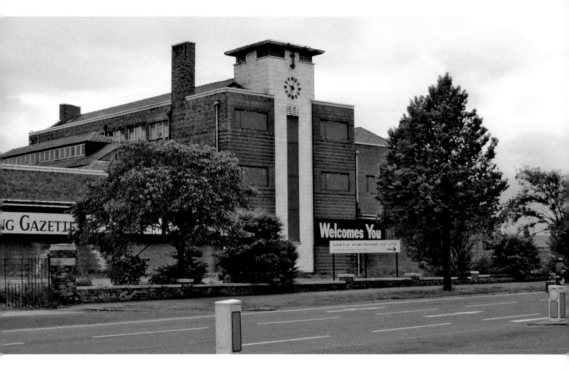

Blackpool Co-op Bakery

In 1935, its golden jubilee year, Blackpool Co-operative Society built a new bakery on Preston New Road. With thirty-eight branches, the Co-op was then the largest trading concern in the area and the decade also saw it build a new diary, a meat products factory and a large emporium in the town. The stylish art deco building, seen here in 1979, was acquired by the Gazette in the 1960s, and used by Empire Pools and the Gazette itself before being sold for housing and a drive-in McDonald's restaurant in 1989.

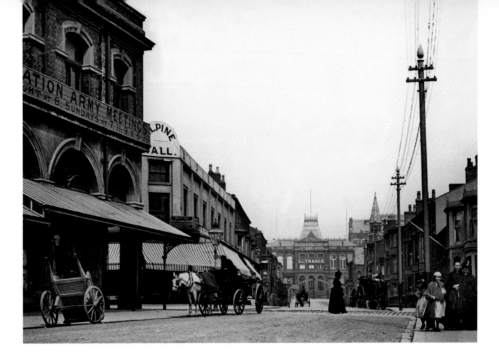

Victoria Street

This is the view up Victoria Street from the Promenade about 1890, with the original Victoria Street entrance to the Winter Gardens in the distance. On the extreme left is the Prince of Wales Theatre and Market. Just beyond it is what is labelled as the Alpine Hall. The building opened in 1837, on what was then Green Walk, as the Victoria Promenade, Blackpool's first public assembly hall, which had seven shop units below. It survived until 2000, when the property was rebuilt.

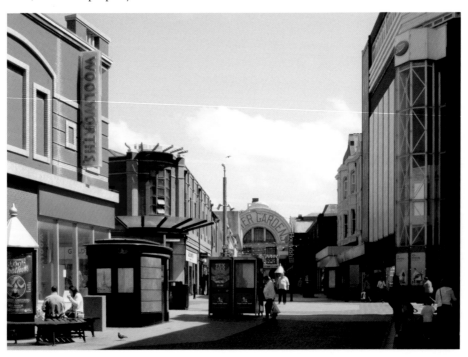

The Little Vic

The eastern end of the Victoria Promenade became a small pub called the Victoria Inn. In 1933 it was rebuilt as the Little Vic, a pub with a façade that combined Art Deco and Spanish influences. Its Spanish style interior (see inset) had plasterwork by Andrew Mazzei, who had designed the Winter Gardens' Spanish Hall two years earlier. It was replaced by shop premises in 1989.

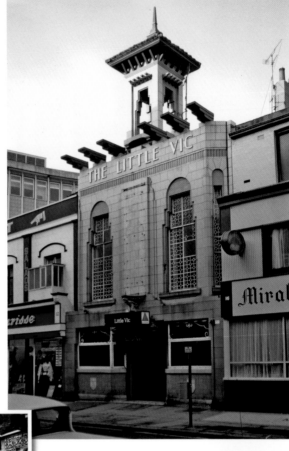

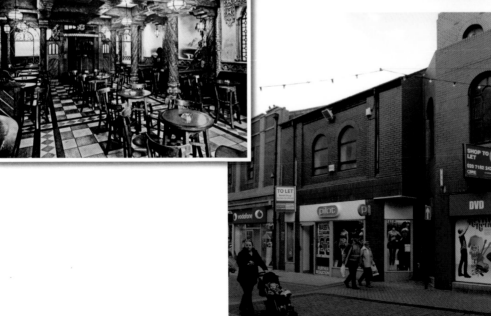

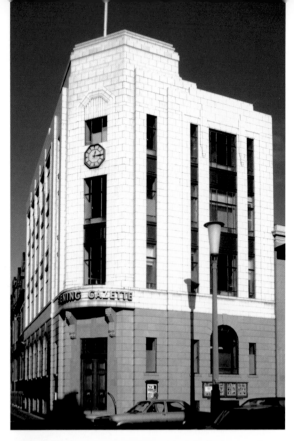

The *Gazette* Office
The *Evening Gazette*'s stylish offices at the corner of Victoria and Temple Streets were designed by local architect Halstead Best and opened in 1934 adjoining its printing works. In 1987 the offices were moved to Cherry Tree Road and later to Squires Gate.

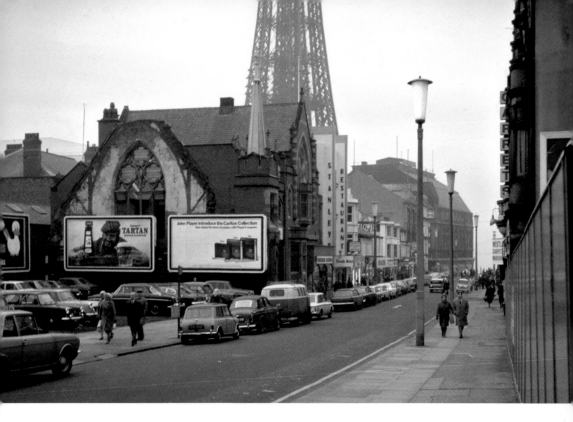

Victoria Street

This is the view down Victoria Street *c.* 1975, following the demolition of the Congregational Chapel of 1849, and before its Sunday School, which opened in 1913, met a similar fate. Beyond is the modernist façade of Stanley's Restaurant, designed by J. C. Derham, which opened in 1935. By 1980, these buildings had been swept away for the Hounds Hill Centre development.

Fylde Water Board

The offices of the Fylde Water Board on Sefton Street, appropriately between Water Street and Board Street, were erected in 1906. They are seen here shortly after demolition work had begun in 1975. These streets have given way to the Hounds Hill shopping centre. A view today from near the same spot is seen below.

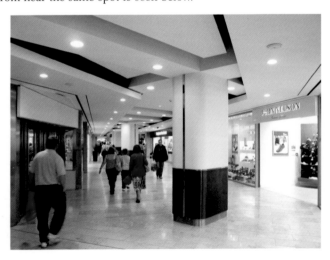

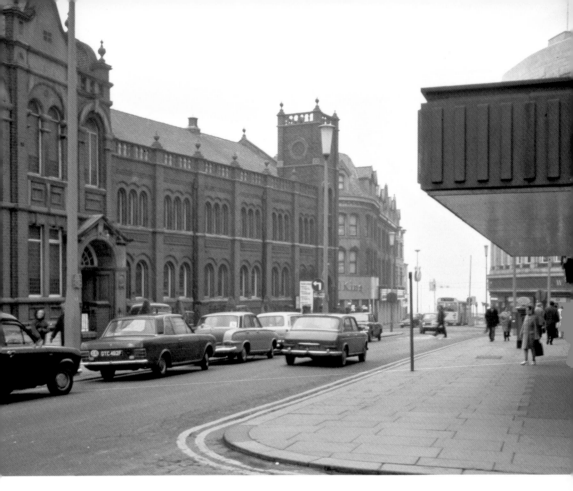

Adelaide Street

The western end of Adelaide Street in 1973, with the Central Methodist Church, built in 1862 but refaced in 1896. Its Sunday School, on the extreme left, was erected in 1913. The church was pulled down in 1972 and modern shops built on its site, with a replacement church above, seen here from the entrance to the Hounds Hill Centre.

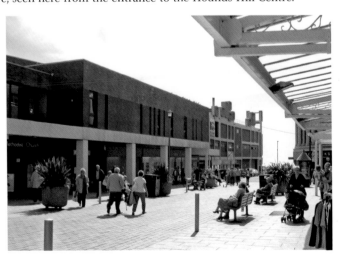

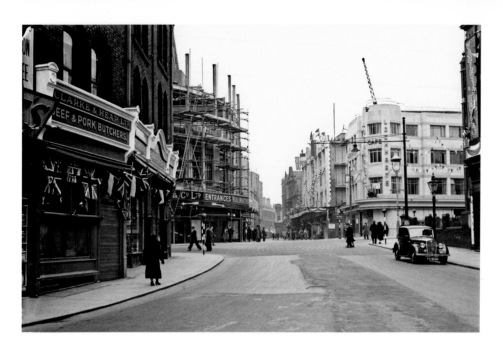

Hounds Hill

Hounds Hill, looking north towards Bank Hey Street in 1937, when the Art Deco Woolworth's superstore was being built next to the Tower. Opposite, a modernist styled Lockhart's Café had recently been completed and, next to it, work had begun on the last extension of R. H. O. Hill's department store. In the foreground on the left is the Palatine Hotel block.

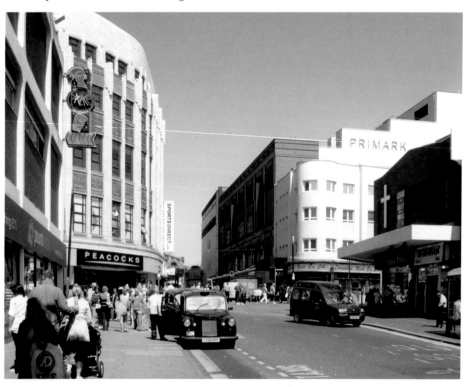

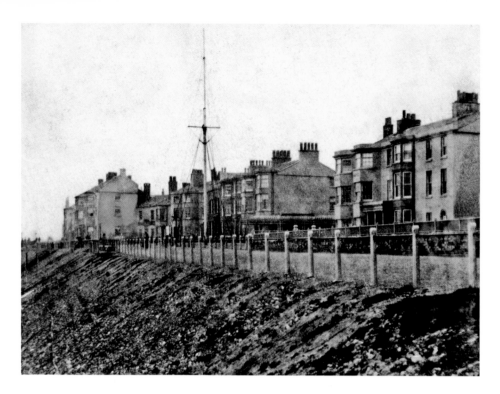

Oldest Known Photograph of Blackpool
This half of a stereoscopic card is possibly the oldest known photograph of Blackpool, and it is the only one to show the original Lane Ends Hotel, which is the taller building on the left. In 1864, it was demolished and rebuilt as the County and Lane Ends Hotel. Between it and the flagstaff on the Parade opposite Victoria Street is the row of houses known as Hygiene Terrace. On the right is the Beach Hotel and Cornwall House, which stood at the northern end of the Tower site.

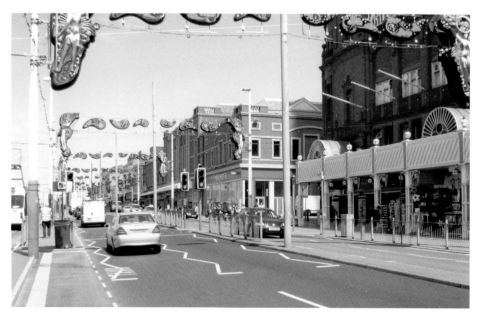

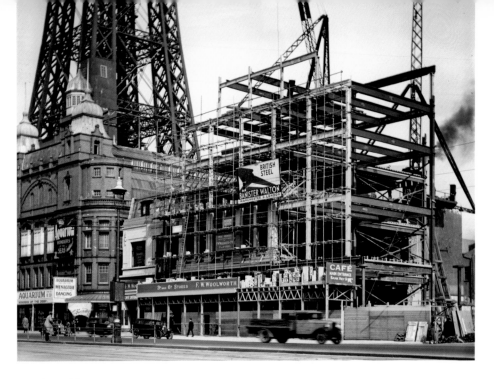

Woolworth's

The new steel frame of the Woolworth's new store is seen from the Promenade in April 1936. To its left the smaller store of ten years earlier operated until parts of the new store could be opened to the public. For that reason there was no grand opening day and its distinctive clock tower was only completed in 1938. On the first floor was probably the largest caféteria in Blackpool, with its own bakery on the roof.

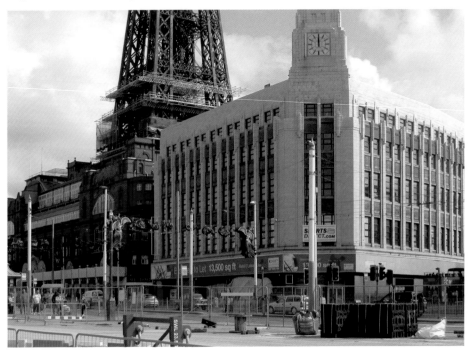

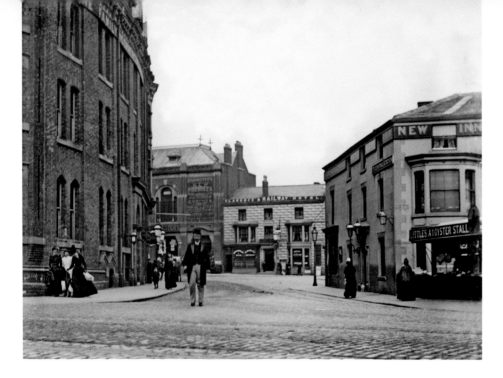

Hounds Hill 1890

This is a view of Hounds Hill in 1890, showing the Palatine Hotel on the left and the New Inn at the start of South Beach, later to become the Golden Mile. The taller building in the background began as the Borough Theatre in 1877, but had recently been taken over as Bannister's Bazaar. Next to it is the Clarence Hotel, demolished in the late 1930s for a Marks & Spencer store.

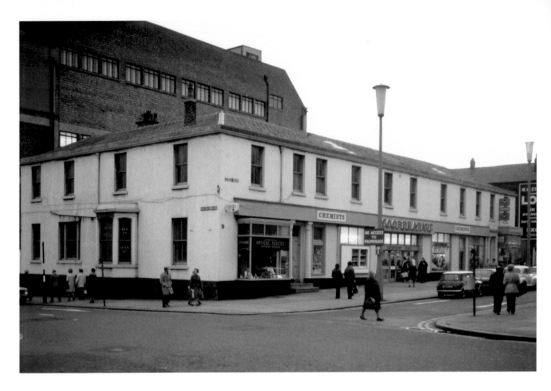

Co-op Emporium

In 1938, the Blackpool Co-operative Society opened its flagship Emporium on Coronation Street, seen in the background of this early 1970s photograph. Boarding houses on Adelaide Street became an extension to the emporium and on the corner of Coronation Street was an optician's, with a dental surgery above. The Emporium's site was cleared in 1988 and became a car park. In 2008, the stores of the refurbished and extended Hounds Hill centre opened on the site. As the name of a shop suggests, it certainly does have a 'New Look' now.

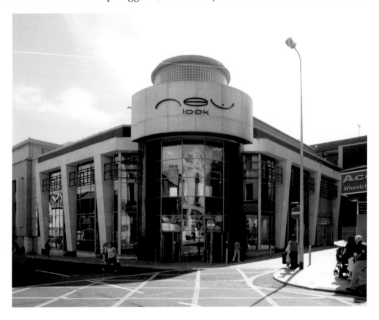

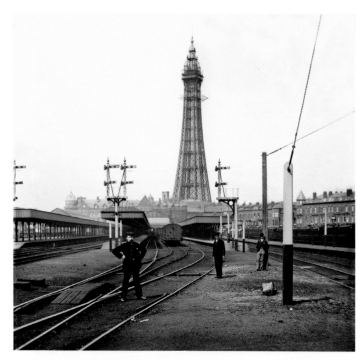

Central Station
The approach to the fourteen platforms of Central Station is seen above, about the time the Tower structure was completed at the end of September 1893. By the time the second photograph was taken in 1968, the railway line had been closed for four years, but the station building and its platform canopies had yet to be removed.

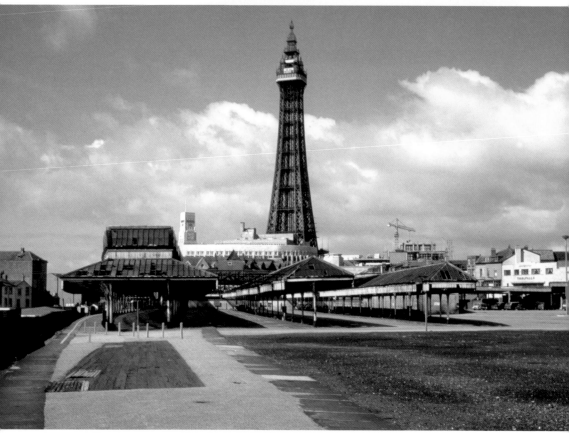

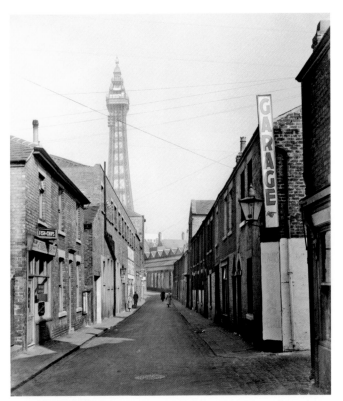

Bonny Street
This is Bonny Street at the rear of the Golden Mile in the early 1950s. In the distance is the cut-through alongside Central Station to Hounds Hill. The mid-nineteenth century cottage property of Bonny's Estate was cleared away in the late 1950s and early 1960s. To the left, in the 2009 photograph, is the rear of the Funland amusement centre and the Sea Life Centre. Opposite to the right, out of view, is the multi storey building of the Lancashire Constabulary which opened on 21 April 1976.

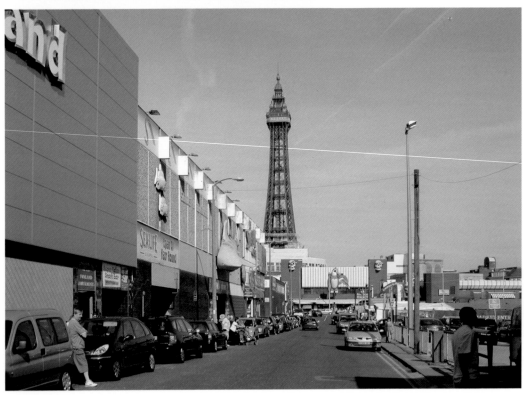

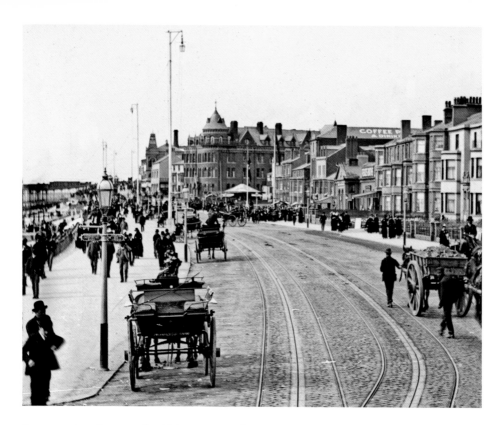

Promenaders Keep to the Right

This is the view looking north along the narrow but often very crowded Promenade, *c.* 1890 – hence a sign on a lamppost requesting that 'Promenaders keep to the right'. The poles supporting Blackpool's original electric arc-lamps of 1879 can be seen, as well as the tramway's conduit track. On the right are the boarding houses of South Beach, which later became part of the Golden Mile.

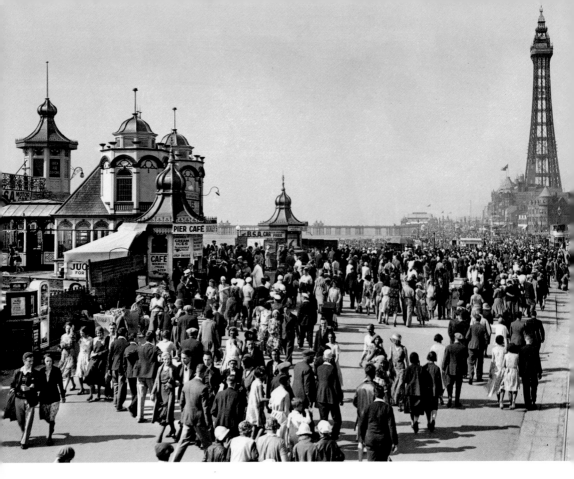

Central Pier

Here is a busy scene at the entrance to the Central Pier, c. 1932. This section of the promenade had been widened by 100 feet in 1904-5, allowing the tramway to be taken off the road.

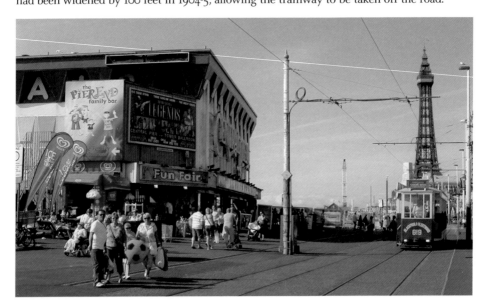

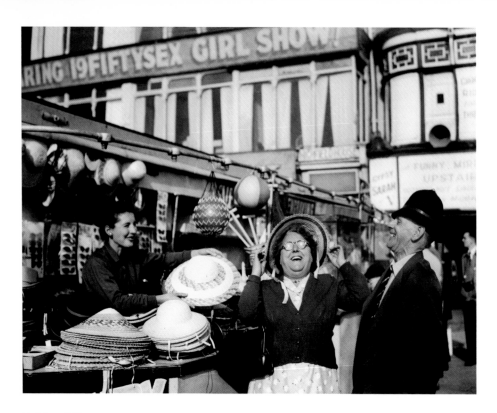

Golden Mile

Despite being arguably improved by modern purpose-built amusement arcades, there is nostalgia for the former improvised and slightly ram-shackled nature of the Golden Mile, which had arisen in the gardens of boarding houses of South Beach. It is perhaps typified by this photograph – apparently taken in 19FIFTYSEX! The second photograph suggests that something of the same character can still be found a little further south along the Promenade.

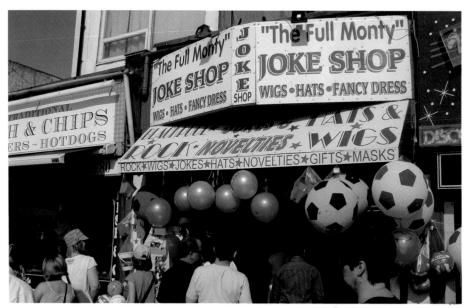

Rigby Road

This is the view east along Rigby Road from the Promenade in the mid-1930s. On the right at the corner of Tyldesley Road is the Plaza Picture Theatre, which opened as the Royal Pavilion in 1909 as Blackpool's first purpose-built cinema. Whilst it is not the most prepossessing early cinema building, it still exists as a fun bar.

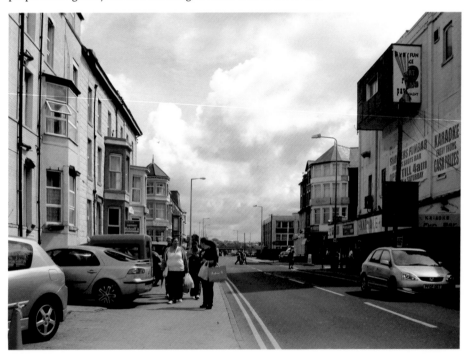

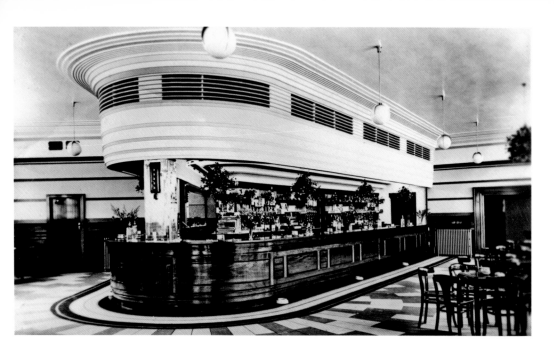

Manchester Hotel

The streamlined bar of the Manchester Hotel, after it had been rebuilt in 1936; this was the year its architect, J. C. Derham, died. His father and brother had both been Chief Constables of Blackpool. The bar survived alterations to the hotel's modernist façade in the 1960s, but the entire hotel was rebuilt in 1996.

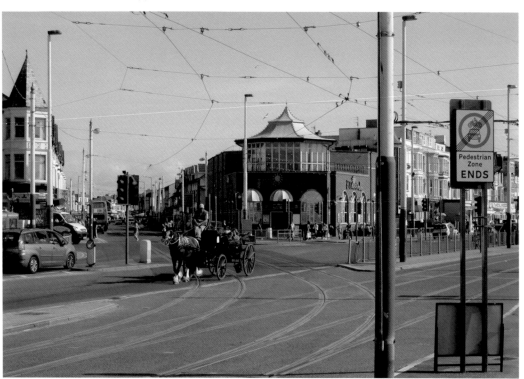

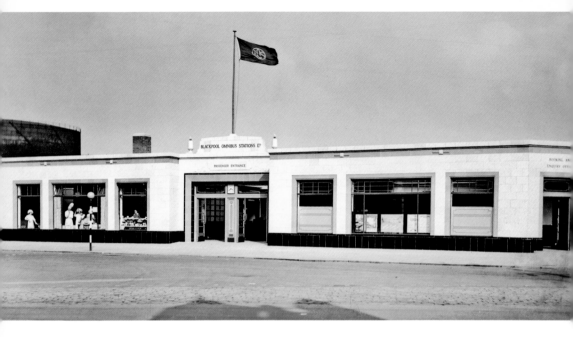

Coliseum Coach Station

This shows the cream and green tiled façade of the Coliseum coach station, as rebuilt in 1936. It was rebuilt again in 1973, but in 1996 it gave way to a supermarket, and from 2008 became a low-cost retail store.

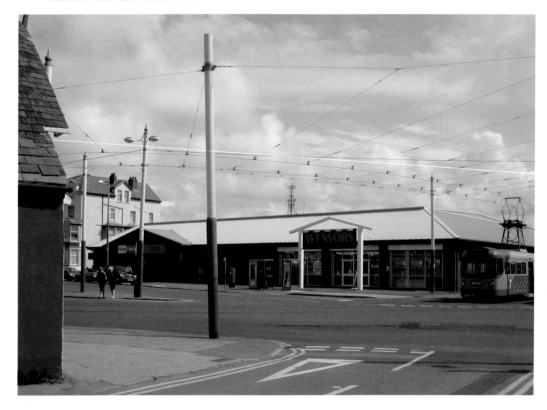

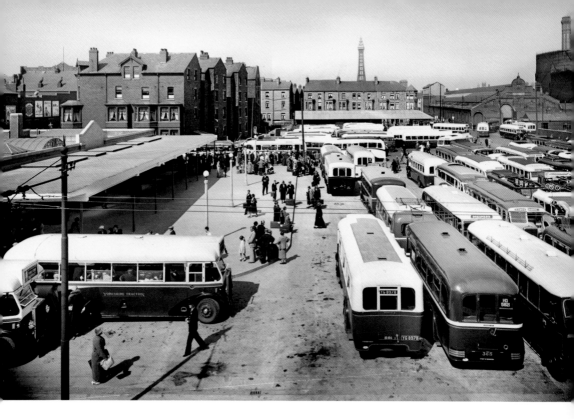

Coaches

This is a busy scene at the Coliseum in the mid-1930s. The previous Coliseum Garage, in the old Niagara building from Raikes Hall, had stood there. In the distance, on the right, is the Corporation's tram shed on Rigby Road.

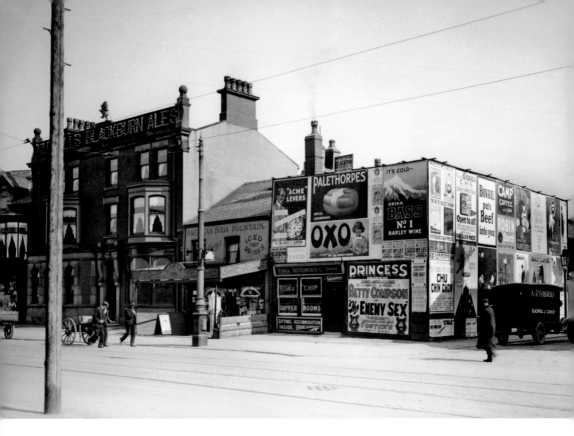

Old Bridge House Hotel

This is the Old Bridge House Hotel on Lytham Road in 1925. The name is thought to refer to its proximity to a bridge at one time over Spen Dyke (the 'black pool' that gave the resort its name) near Manchester Square. The pub was rebuilt shortly before it obtained a full license in 1879 and it was re-modelled in the 1930s.

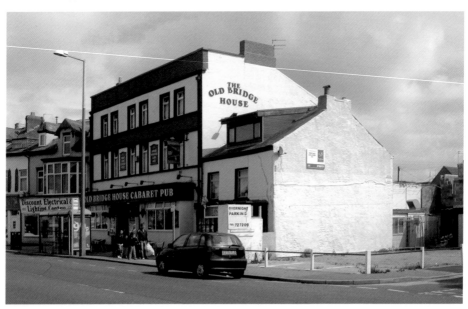

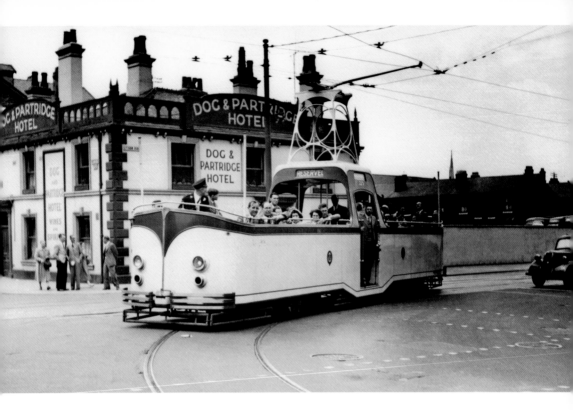

A Boat Tram

A boat tram carrying visiting tram enthusiasts is shown turning from Lytham Road into Waterloo Road by the Dog and Partridge in June 1954. The pub was rebuilt in 1959, and set further back.

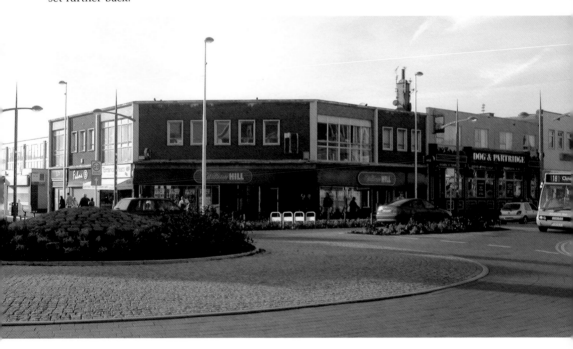

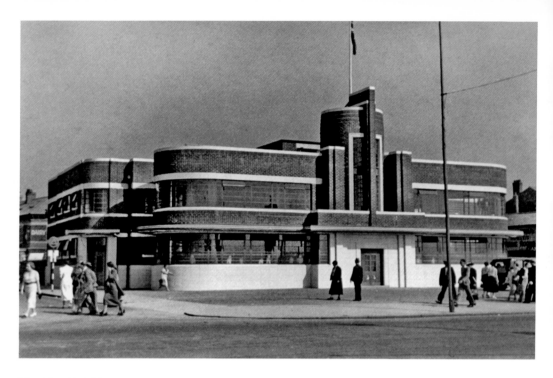

The Lion Hotel

The Lion Hotel on the Promenade at South Shore, seen here when it was new in 1938, was one of many Blackpool buildings designed in the 1930s by Halstead Best, whose name became synonymous locally with ultra-modern architecture. In the 1990s, the pub was taken over by Yates's and has been much altered.

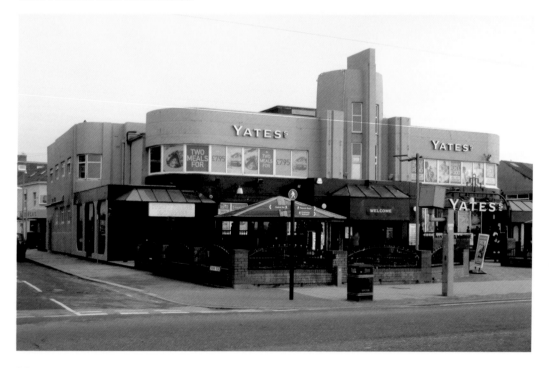

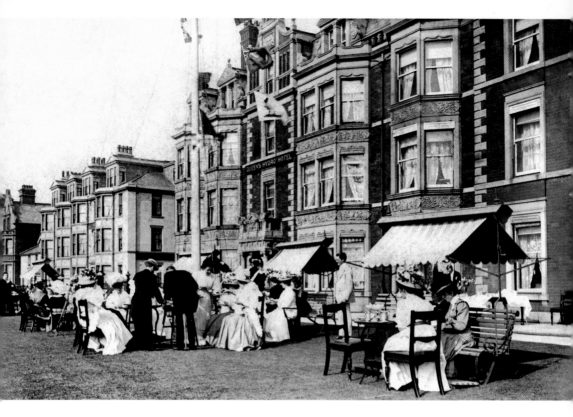

Queen's Hydro Hotel

Afternoon tea on the lawn of the Queen's Hydro hotel, on an Edwardian summer's day, seems a far cry from manoeuvring in the tarmac car park of the Queen's Hotel, as it is now called. In 1882, the premises of what were once the Merchants College, and the College Français before it, had been enlarged to become the South Shore Hydropathic Establishment, which was developed into the Queens Hydro hotel in the late 1890s.

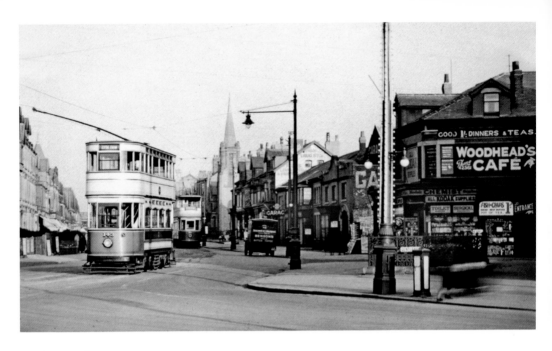

Station Road

Station Road, as well as leading to the South Shore Railway Station at its eastern end, was the road along which trams left the Promenade towards Central Station via Waterloo Road and Central Drive, as in the case of the tram in the foreground, or on to the Marton route and Whitegate Drive.

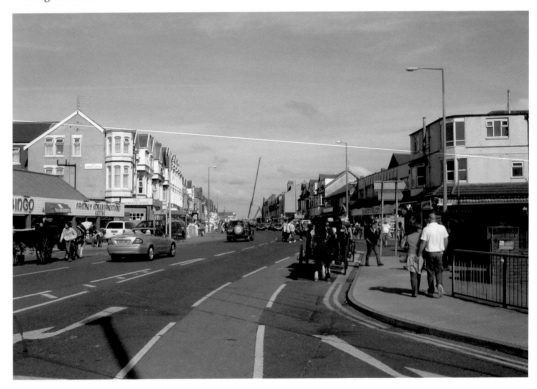

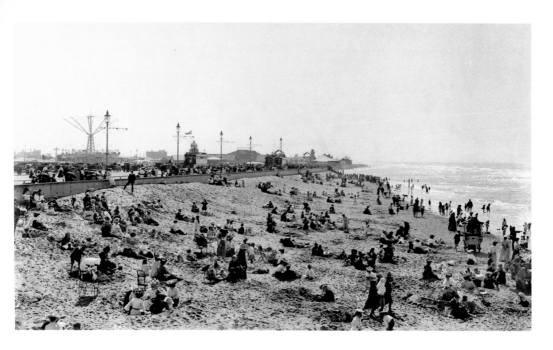

South from Victoria Pier

This is the view looking south from Victoria (now South) Pier in 1906. At that time the Promenade ended at Balmoral Road, a convenient terminus for tram passengers wishing to visit the quickly evolving Pleasure Beach beyond. Its thrills already included the Captive Flying Machines, the Helter-Skelter Lighthouse, the River Caves, a Switchback Railway and the Sea Circus.

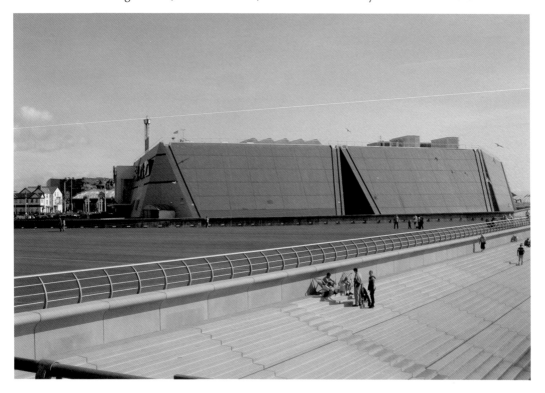

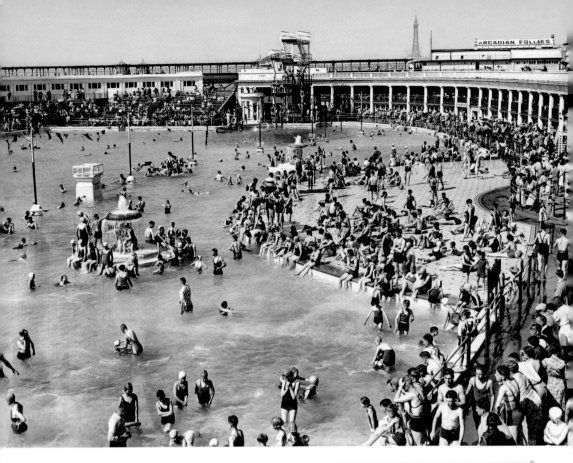

South Shore Open Air Baths

In June 1923, South Shore Open Air Baths, the world's largest, opened on what had been the beach in the foreground of the photograph on the previous page. The baths were demolished in March 1983 (see inset) and the Sandcastle indoor water centre opened on the site in 1986.

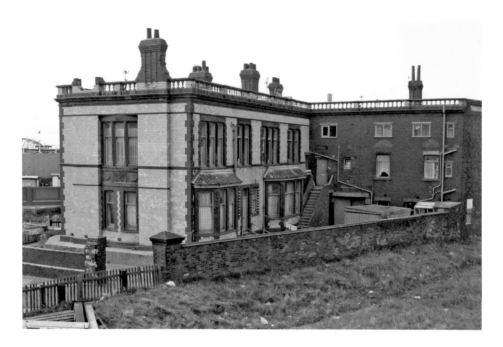

Burlington House

Burlington House was built by Councillor John Hall, in the 1890s, looking out onto sand dunes and the sea. In 1902, Hall objected to a switchback being re-erected, blocking his view of the sea. He did not live to see the ensuing development of the Pleasure Beach, as in April 1903 he was killed by a train on the level crossing by his house. A footbridge has replaced the crossing, and Burlington House was demolished in the 1980s. The land is now the car park of the Pleasure Beach Station.

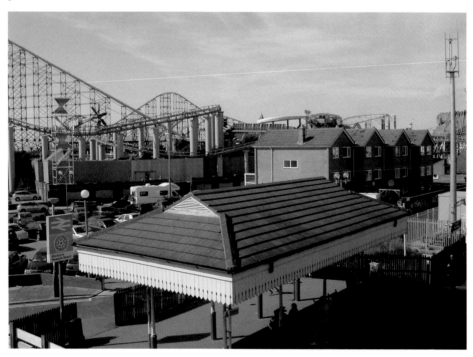

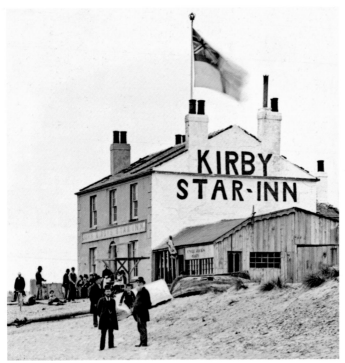

The Star Inn

The Star Inn was built in the sand dunes at South Shore in the 1850s and was originally called the Seven Stars. It is seen here in the 1890s, when landlord John Kirby had a wooden building on the south side called 'Uncle Jack's Cabin'. The building of a sea wall in 1923, 400 feet to the west of the pub took it away from the water's edge. In 1931, it was replaced by the Star Hotel, built well in front of it.

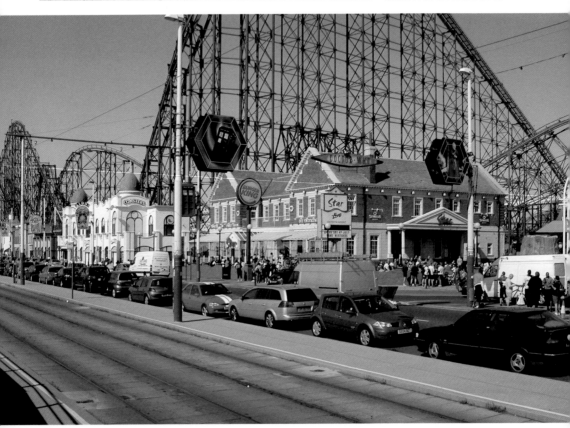

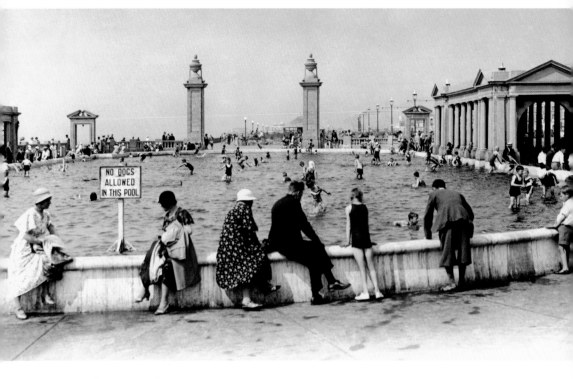

New South Promenade

The building of a sea wall as far as Starr Gate allowed the completion of the New South Promenade, which officially opened in October 1926. It featured sunken gardens and fine circular shelters. The central feature was this paddling and model yacht pool at Harrowside, which was surrounded by neo-classical shelters and pylons. In 1996 work began on a new sea wall promenade and the neo-classical theme was superseded by modern artwork and impractical shelters, each resembling a motorway flyover stanchion combined with a stainless steel urinal.

95

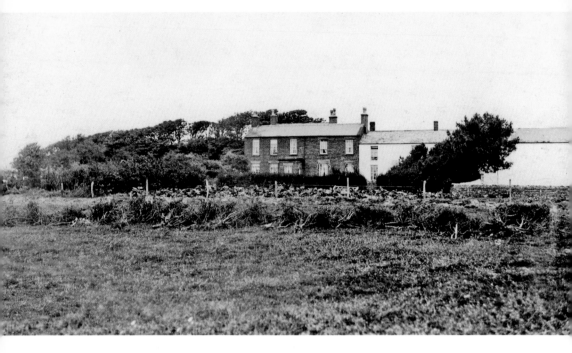

Layton Hawes Farm

Layton Hawes Farm faced south on what is now Blackpool Airport, almost opposite Abbey Road. In 1910, the trees around it were cleared away for the Air Carnival in August that year, and the following year the farmhouse was pulled down for the short-lived Clifton Park Racecourse. The enclosure of Layton Hawes in 1769 had seen land south of Squires Gate Lane allocated to the Cliftons of Lytham, and it became part of St. Annes-on-Sea a century later, despite being north of Division Lane, the old boundary with Lytham.